ACRYLIC LANDSCAPES
FOR BEGINNERS

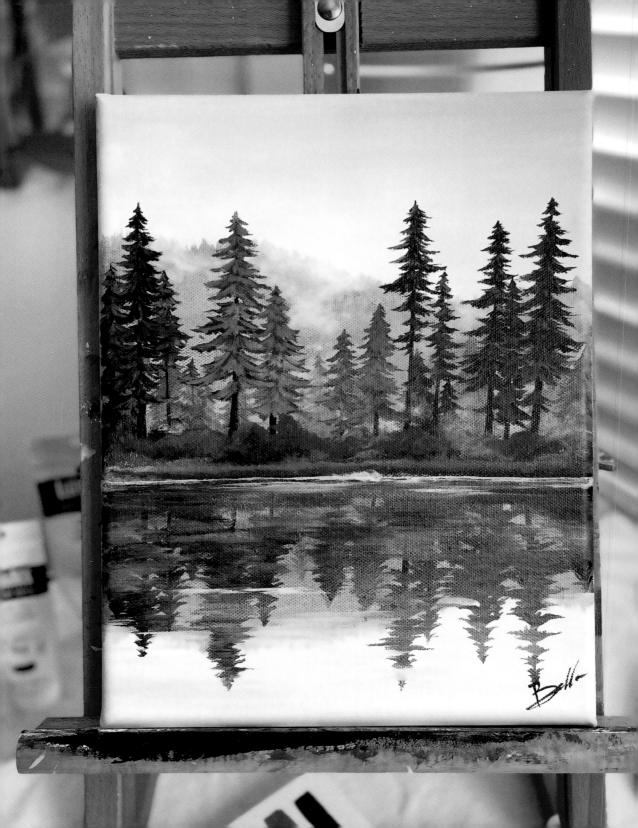

ACRYLIC LANDSCAPES
FOR BEGINNERS

Your Step-by-Step Guide to Painting Scenic Drives, Misty Forests,
Snowy Mountains and More

SARAH JOHNSTON

Creator of Brellian

PAGE STREET
PUBLISHING CO.

PAGE STREET
PUBLISHING CO.

Copyright © 2024 Sarah Johnston

First published in 2024 by
Page Street Publishing Co.
27 Congress Street, Suite 1511
Salem, MA 01970
www.pagestreetpublishing.com

Distributed by Macmillan, sales in Canada by The Canadian Manda Group.

28 27 26 25 24 2 3 4 5

ISBN-13: 978-1-64567-853-3
ISBN-10: 1-64567-853-9

Library of Congress Control Number: 2023936577

Edited by Sadie Hofmeester
Cover and book design by Rosie Stewart for Page Street Publishing Co.
Photography by Sarah Johnston

Printed and bound in the United States of America

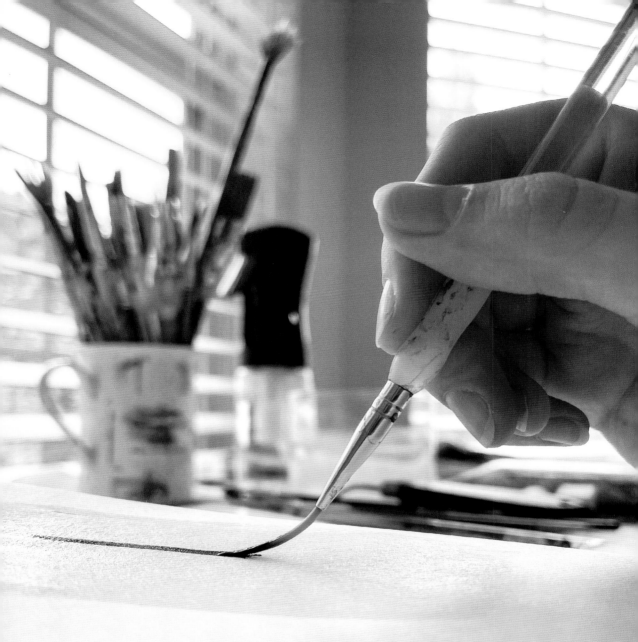

DEDICATION

For my son, Bobby, who fills my days with joy and inspiration.

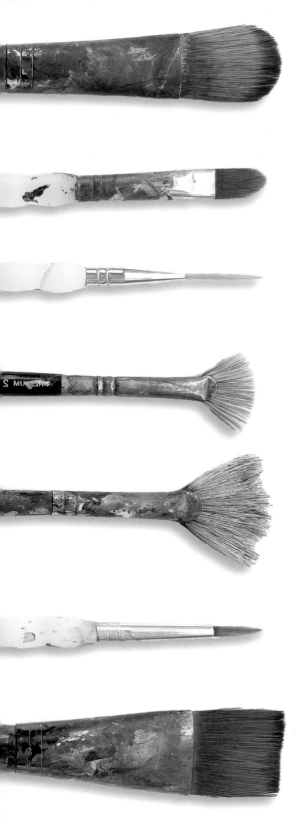

CONTENTS

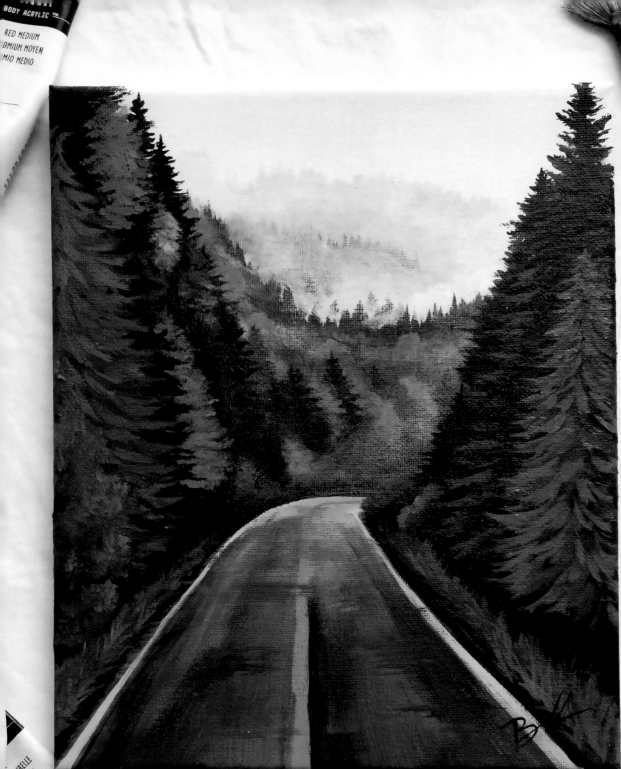

INTRODUCTION

I have always been a creative person. Since I was a child, I have loved to get my hands dirty and create things from nothing. It started out with crayons and has led to acrylic paints. Whether you have just picked up a creative practice or you have been creating for a long time, the journey is incredibly fulfilling, and I hope that your soul sparks with inspiration as you work through the projects in this book.

As artists, we have the power to create worlds with our own hands. Some days it is easy to paint these worlds into existence, and other times it feels incredibly difficult. Not only are you trying to interpret the image in your mind, but you also have to pay attention to drying times, color schemes, composition and so much more while you paint. My hope with this book is to teach you the tools in my toolbox that will allow you to paint any landscape you can dream up, with less overwhelm and more inspiration.

This book is filled with a variety of landscapes. Each one is a window into a different geography, a different time of year, a different memory, a different set of skills. The wild and free nature of clouds drifts next to the steady strength of mountains. There are bright, saturated landscapes paired with moody, mist-filled forests. Each landscape is approached with awe and in honor of the world around us, with paints and tools shaped from the materials the earth has gifted us. Let's explore this painting journey together and learn some skills to set your creative soul free.

YOUR STUDIO

There are so many kinds of art supplies out there and it can be hard to figure out which ones you need. There is always a bit of personal preference when it comes to supplies, but there are also some guidelines that make it a lot easier to decipher what tools are the best for you. In this chapter, I will walk you through the different tools that I find most important for acrylic painting and why.

BEGINNER'S GUIDE TO ART SUPPLY SHOPPING

Shopping for paints and painting supplies can be daunting. There are so many brands, levels and colors! How can you possibly figure out which things you should buy?

I've been there. Sometimes you just have to stand in the aisle of the craft store and stare at the rows of paints and brushes for a while before you have any idea where to start. Let's go through it.

The craft store can feel like a never-ending sea of indistinct art supplies. If it feels like that, look closer. Step up to each section and look at the different brands. Art supply brands often provide charts and descriptions of their products to make shopping easier.

This information may be on the products or in a booklet that the store puts on the shelves for your convenience. For example, Strathmore® brand drawing pads contain a chart inside the front cover that breaks down which papers work best with which mediums. Another great tool to look out for is the information on paintbrush stands. The organizational stands that most stores use to hold single brushes typically have a sign attached to the front of each section explaining what brushes you can find there and what they are typically used for.

Along the same lines, paint brands usually offer a color chart of the different colors they carry. The best ones to look at are those with actual paint on the page or tube rather than the printed ones, as printers aren't always accurate.

PAINT COLORS

When shopping for acrylic paints, you'll find many different colors at the store and even more options online. I have compiled a list of colors that I believe all artists should have in their toolboxes. These colors will allow you to mix just about any color you may need and will let you paint every project in this book. This doesn't mean you will never have a use for any other color, but the twelve colors below are a good place to start.

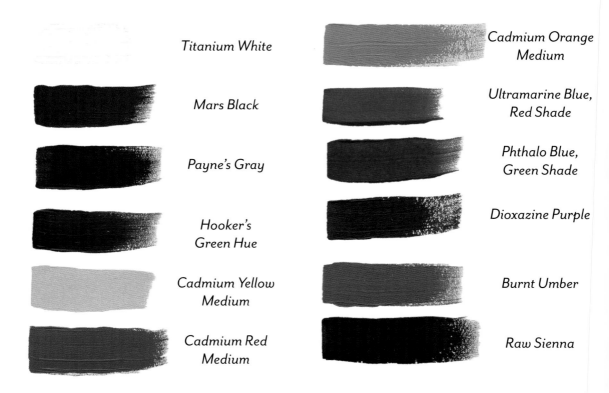

Titanium White

Mars Black

Payne's Gray

Hooker's Green Hue

Cadmium Yellow Medium

Cadmium Red Medium

Cadmium Orange Medium

Ultramarine Blue, Red Shade

Phthalo Blue, Green Shade

Dioxazine Purple

Burnt Umber

Raw Sienna

ABOUT ACRYLIC PAINT

Acrylic paint is composed of pigments suspended in a water-based acrylic polymer emulsion. As opposed to oil paints, which are made with vegetable oil and dry slowly, acrylic paints dry quite quickly as the water in the binder evaporates.

Advantages

The major advantages of acrylic paints are their permanence, their resistance to aging and their flexibility. Oil paints harden as they dry and can become brittle and cracked as they age. Acrylic paints are formulated to remain flexible and don't yellow over time. Another advantage is that acrylic paints are water soluble. This allows you to wash your painting materials without using a solvent.

Disadvantages

Acrylic paints dry quickly. There are a few drawbacks to their quick-drying nature. It is tougher to blend your colors, it can be tough to take care of your paintbrushes, and you must maintain the paint on your palette so it doesn't dry before you're done working. Because acrylic paints are permanent when they dry, you must be proactive about keeping your space and your materials clean.

It's also important to note that your paints may look different when they're wet than when they're dry. I wouldn't necessarily call this a disadvantage, but it is certainly something to be mindful of. Because the pigments and resin are suspended in water, when the water evaporates and the paint dries, it will look less "milky" and slightly darker. The difference is usually minimal, but it is something to keep an eye on.

Types of Paint

There are several different kinds of acrylic paints. The main types available at craft stores are:

- *Professional Grade*
- *Student Grade*
- *Heavy Body*
- *Soft Body*

Artist/Professional Quality vs. Student Grade

Professional-quality paints are made with pure pigments and are formulated to contain fewer additives and mediums. This often leads to different paints drying with different finishes depending on the pigments they contain.

Student-grade paints are often in a lower price range and, because of this, are not made with the same quality pigments that professional paints are made with. The expensive pure pigments are replaced with less-expensive alternatives and have more additives and mediums mixed into the formula. This leaves them a little more transparent, and the colors are slightly different. For example, Hooker's Green Hue in a professional line of acrylic paints is darker and more opaque, while Hooker's Green Hue in student-grade acrylics is more vibrant, lighter and less opaque. A big plus for student-grade paints, though, is that most of them dry with the same finish, so it's easier for beginners to predict how the paints will act.

In this book, I use Liquitex® Professional Heavy Body and Soft Body paints. I use these the most in my personal collection. It does not matter what type of paint you use while working through this book.

If you are a beginner artist, don't feel like you need to jump headfirst into buying expensive professional paint. It is perfectly okay, and even recommended, to start with student-grade paints while you are learning. Liquitex® and Artist's Loft® both have wonderful student-grade paints.

Heavy Body vs. Soft Body

Heavy body paints are thick and hold a lot of texture. These are good for artists who want to retain the texture of their brushstrokes.

Soft body paints are smooth and fluid while remaining opaque and highly pigmented. They work well with synthetic brushes and help you with small details and smoother paintings.

A Few More Terms

There are a handful of terms used when talking about paints that I want you to know.

There is so much specific vocabulary in the art world that it is practically a language of its own. Acrylic paints have their own set of terms to help you decide which paint will be the best for your project. You don't need to memorize each one, but they are useful to know. Here are a few terms explained:

Hue

A paint with the word "hue" in the title does not contain the original pigment it's named for, for one reason or another. This may be due to the cost of the pigment or because the original material is toxic. For example, a cadmium hue paint contains something that resembles cadmium but does not actually contain cadmium.

Lightfastness

Lightfastness is a property of a pigment that describes how long it will resist fading. Each pigment's lightfastness is rated on a scale by the American Society for Testing & Materials (ASTM) and is usually listed on the paint tube or on the box the paint comes in.

Opacity and Transparency

Opacity and transparency tell you how see-through the paints are. This is also printed on the bottle or box of some brands. Opaque paints are formulated to not allow light through the color layer. Transparent paints provide the least amount of coverage and allow the most light to pass through. Semiopaque paints land between opaque and transparent, allowing some light through the color layer.

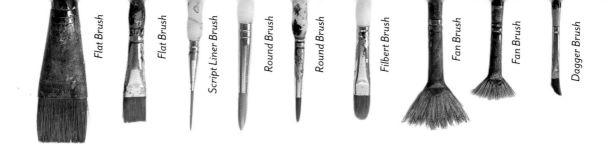

Flat Brush *Flat Brush* *Script Liner Brush* *Round Brush* *Round Brush* *Filbert Brush* *Fan Brush* *Fan Brush* *Dagger Brush*

PAINTBRUSH SHAPES AND WHAT THEY ARE USED FOR

The type of brushes you'll use mostly comes down to personal preference and your individual painting style. There are different brush shapes, sizes, handle lengths and bristle types to consider. My favorite paintbrushes are the clear-handled Royal & Langnickel® brushes and the KINGART® Original Gold Series brushes.

Flat or Wash Brush

These brushes have square, flexible ends and can hold a lot of paint. When used flat, they can make long strokes and are well suited to blending and painting in large areas. The tip and sides can also be used for more delicate lines and small touches.

A flat brush is one of the most common and useful brushes you can own. I recommend having a ½-inch (1.3-cm) flat brush for smaller projects or details and a 1-inch (2.5-cm) flat brush for larger spaces.

Script Liner Brush

These brushes have long, thin hairs that taper to a point. The length of the brush's hair affects the amount of paint that the brush can hold. The longer the liner, the more control is required. This type of brush is well suited for long looping scrolls or borders, straight lines or stroke work.

I recommend having at least one of these brushes in your toolbox. In this book, I use a #2 script liner by Royal & Langnickel.

Round Brush

These brushes have a large belly that tapers to a fine point. They're capable of bold strokes that can cover large areas, yet they can also render fine lines and details.

A round brush is another incredibly common and useful brush that I think everyone needs. In this book, I use a #4 round brush for my projects.

Filbert Brush

A filbert brush is like a flat brush but with a tapered, rounded end. Capable of a variety of marks, it is especially useful for blending.

I really think that this brush is underrated! I love it for painting clouds and trees. In this book, I use a ½-inch (1.3-cm) filbert brush, but I also recommend a 1-inch (2.5-cm) filbert brush for larger projects and spaces.

Fan Brush

This brush's traditional use is blending colors or softening hard edges. I also use it to give texture to leaves and grass.

The fan brushes that we will be using in this book are made with boar hair bristles and are rather stiff. I prefer boar hair fan brushes for my paintings because they hold a lot of paint and keep their shape well when applying the paint to the canvas.

I use two sizes of fan brush in this book, a #2 fan brush and a #8 fan brush.

Dagger Brush

The dagger brush has a unique shape, featuring a wide base (similar to a flat brush) that tapers into a sharp point on one side. This is a very versatile brush that allows you to create long, thin lines with the tip and thick, expressive strokes with the flat edge of the brush.

In this book, I use a ⅛-inch (3-mm) dagger brush.

Long Handle vs. Short Handle Brushes

Long handle brushes are used for larger paintings and to give artists some distance between themselves and their project.

Short handle brushes are best for details and smaller-scale work. I personally use short handle brushes.

Hog Hair vs. Synthetic Bristles

Hog hair and other natural bristles are stiffer than synthetic bristles. They are used most often with oil paints and thick acrylic paints. The only natural bristle brushes that I use when I paint are fan brushes.

Synthetic brushes are softer, more pliable and more suitable for acrylic painting. They work well with more fluid paints and allow you to create smoother lines. Most of my brushes have synthetic hair bristles.

MAINTAINING YOUR BRUSHES

Day-to-day maintenance for paintbrushes is not very extensive. There are a handful of guidelines that will help your brushes last longer if you follow them.

1. Keep two water jars with you while you paint. Use one for washing the paint from your brush and the other for clean water to use during color mixing and painting.

2. Do not leave your brushes in water for an extended period of time. Paint brushes should not be in the water for more than an hour or two. Letting them soak can cause the wooden handle to swell and the glue in the bristles to rot. Not to mention that the bristles are not meant to hold the weight of the brush's handle and will start to fray and warp over time.

3. Make sure to wash your brushes thoroughly when you are done with them. Lay them flat on a paper towel or cloth when you are done painting to allow them to dry.

To clean your brushes, rinse them thoroughly in clean water to remove as much paint as you can. Once the water runs clear, use a brush conditioner or paintbrush cleaner to gently wash the bristles between your fingers or on your palm. Specially made artist soap is recommended, as it is formulated to condition the brushes and not dry them out as some household soaps do (I recommend Speedball Pink Soap or The Masters Brush Cleaner and Preserver). Rinse the soap out of the brush thoroughly, gently smooth the bristles back into shape and rest the brush horizontally on a paper towel or cloth to dry.

Once dry, you can store your brushes with the bristles up. I keep mine in a cup on my desk.

CANVASES AND PAINTING SURFACES

There are many painting surface options available for artists these days. A few of them are:

* *Canvases*
* *Canvas Boards*
* *Canvas Paper*
* *Multimedia Paper*

Canvas Boards and Panels

If you find that stretched canvases take up too much space, canvas boards and panels are a great alternative. These surfaces are much thinner and easier to store in a small space. Canvas panels are often less expensive than stretched canvases and are easier to travel with, as you don't need to worry as much about puncturing the canvas or warping the surface. I have many students who use these. One issue with canvas boards and panels is that they tend to look unfinished and less professional. You can dress them up with a frame, but stretched canvases are regarded as more professional and polished.

Acrylic Grade Paper

I use two main supplies for small projects and for practice: canvas paper and multimedia sketchbooks.

Because canvas paper is relatively inexpensive, it's perfect for practicing and testing new techniques. For a beginner, this is a fantastic way to try out a variety of techniques, colors, styles and brushes with the authentic texture and feel of canvas—without breaking the bank. Canvas paper can take the pressure out of the painting process, allowing you to explore, make mistakes and develop skills. My favorite canvas paper to use is the Strathmore 300 Series Canvas Paper Pad.

Multimedia sketchbooks are also readily available in a lower price range. The biggest plus to these is that the paper stays together, so you won't end up with tons of loose papers to take care of. The mixed media sketchbook I use is by Master's Touch and comes in a few different sizes.

Acrylics can be used on just about any surface. The only things to watch out for are materials primed for oil paint use. Acrylic paints will not adhere to surfaces primed with oil or wax, and those surfaces will cause issues for you. In this book, we will only be painting on stretched canvases primed specifically for acrylic paints.

Canvas

We will be using stretched canvases in this book! I almost always use stretched canvas for my paintings. The texture of the canvas is something to keep an eye on as you shop for the right one. Canvases with more texture are great for larger compositions and highly textured paintings while canvases with a smoother surface work better for small paintings and finer details. Linen canvas is widely considered the best canvas for painting. Paint adheres well to the textured surface and linen resists aging and warping over time.

TOOLS FOR SUCCESSFUL PAINTING

There are many tools for artists and so many options for each one. I have a handful of tools that I use every single time I paint and think will be great for you to have in your own painting toolbox.

WATER JARS

Water jars are used to wet your brushes and to wash them between colors. I recommend using two water jars to separate the paint-filled and muddy cleaning water from the fresh water for color mixing and loading your brush.

PAPER TOWELS OR CLOTH

These are used to dry your brushes as needed and occasionally to add textures or fog to a painting.

PALETTE

A palette is the surface where you store your paint and mix colors while you are painting. I use palette paper, but there are many other alternatives. Palette paper (I use Strathmore brand) is a disposable substitute for a reusable palette. The smooth, white-surfaced paper is easy to use and does not need to be cleaned like a traditional palette.

MIST BOTTLE

I use a mist bottle to lightly mist the paint on my palette to keep it from drying out too quickly.

KNEADED ERASER

I keep my canvas from moving while I paint with it flat on a table by tacking the corners down with little bits of kneaded eraser. I also use this if I need to lighten pencil lines on a painting or sketch before painting to keep the graphite from mixing with my paint and muddying my colors. There are many brands that sell kneaded erasers, but I use Prismacolor erasers.

PENCIL

Every toolbox needs a pencil. You might need one to sketch the composition of your painting onto the canvas before painting it or to take notes during your creative process. I always have a #2 pencil with me. Just about any pencil will work.

APRON

Aprons or smocks are often worn during painting to keep your clothes from getting stained as you work.

PALETTE KNIFE

Palette knives are used to mix paint colors on your palette and occasionally to add an interesting texture to your painting. I prefer not to use palette knives during my painting process, using a brush to mix my colors instead. Choosing whether or not to use a palette knife is a personal preference among artists.

YOUR WORKSPACE

Whether your studio is in a large and airy space or just in the corner of a room, it should be comfortable, well lit and well organized. You will probably be storing your materials and paintings in this space as well. There is no hard-and-fast rule for how you should organize the space you create in. The most important thing is that everything is safely stored and easy to access.

I set up my painting desk the same way every time I sit down to paint. This system works well for me and allows me to create without having to break my concentration to wash my brush or look for something. I set up my painting in the center of the table with my palette on the left-hand side and my towel and water jars on the right. I do this because my right hand is my dominant hand and will be reaching around to take care of my brushes the most. I also do this to avoid setting my arm in my palette and spreading paint everywhere in the process. I am a messy painter, so I will end up with paint on myself somehow.

It may take some time to establish your routine, but it is so worth it to try out a few things until something clicks.

Paintbrush Cheat Sheet

ound Brush

Wash brush

Blendin

Round Brush

Side to Side

Wash Brus'

ough
water

mucr
ater

ART THEORY 101

The art world is FULL of different terms, techniques and scientific knowledge that can feel impossible to take in—especially as a beginner. You don't need to memorize these things or feel restricted by them, like you have no creative freedom. These terms and techniques exist to take your incredible artwork and push it to the next level.

COLOR THEORY AND COLOR MIXING

WHAT IS COLOR THEORY?

Color theory is a collection of rules and guidelines that helps you understand the relationship between colors and the psychological impacts of certain color combinations. You don't need to worry about all the complex and scientific details of color theory, but understanding the relationship between colors is one of the fundamental building blocks for artists.

The color wheel is a visual tool used by artists that defines colors and the relationships between them. The typical color wheel is made up of twelve colors and shows the positions of three different color groupings: primary, secondary and tertiary.

The three primary colors are red, blue and yellow. Primary colors are called primary colors for a few reasons. First, these three colors cannot be made by mixing other colors; they are only made with natural pigments. Second, the other colors on the color wheel are made by mixing two or more of these colors together.

The three secondary colors are green, orange and purple. Secondary colors are made by mixing equal parts of two of the primary colors. Blue and yellow will give you green. Yellow and red create orange. Red and blue make purple.

There are six tertiary colors. Tertiary colors are created by mixing a primary color with a secondary color. Using the primary colors, you can mix pretty much any color in the spectrum. This is why a solid knowledge of color theory is so important when it comes to painting and mixing your colors.

COLOR THEORY TERMS

Here are a handful of terms that I will use throughout the book and that are used throughout the art world. Not only are they good words to add to your vocabulary, they can completely change the way you see your artwork and can help you problem-solve when you hit a roadblock.

Hue

The term *hue* is often used as a synonym for *color*. Hue generally refers to a paint's dominant color out of the twelve colors on the color wheel. For example, the hue of navy is blue and the hue of burgundy is red.

Saturation

Saturation is a measure of how pure a color is. If you have a photo that is fully saturated, it will be vibrant and full of color. Conversely, if you completely desaturate a photo it will be in black and white. You usually see this in photo editing, but it is a great tool to use while you are painting. You can reduce the saturation of a color by adding gray or a complementary color (a color on the opposite side of the color wheel). Mixing a complementary hue to your color will help mute the vibrancy and desaturate the color.

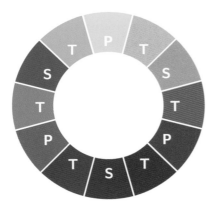

P = Primary, S = Secondary, T = Tertiary

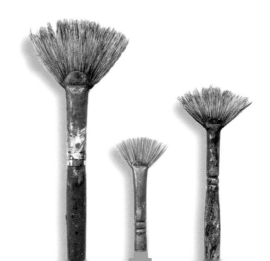

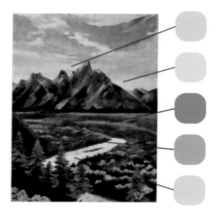

Here, I pulled out a handful of colors that have pretty different hues from each other.

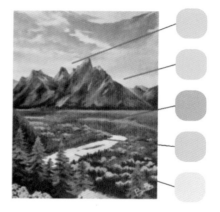

Once desaturated, the values in the painting are exposed. Despite being different hues, the values are rather similar.

Tone

Tone describes all the color variations that can be made from a pure color. Imagine the range of colors between baby blue and midnight blue. Every color on the color wheel has an almost unlimited number of tones, from the very lightest version of the color to the darkest.

Value

Value is how light or dark a color is on a scale of black to white. If you desaturated a painting in a photo editing app so you were simply left with a grayscale image, some of the colors would appear very light and others would appear very dark. Value is widely considered to be one of the most important variables to the success of a painting. I have a general rule that helps me while painting: When you want to increase (lighten) the value of a color, add white and/or yellow. When you want to decrease (darken) the value of a color, add blue, black and/or raw umber. This rule does bend as you work on your paintings. Make sure to take into account the overall color scheme of your painting before mixing a color that doesn't quite fit in.

One interesting thing is that you can have different colors which have the same value. If you take color out of the picture, then you will be left with just a range of black to white colors, with black being the lowest and white being the highest value. When you look at a photo made up solely of values, you will find many of the shades are similar but would not be the same color when saturated. As an illustration, I have desaturated my Sun Setting in the Tetons painting (page 95) to show you how similar these colors are in value, though they are quite different in hue.

Value is widely considered by artists to be more important than color in a painting. This is because value really sets the structure of your painting, creating a sense of depth with highlights and shadows. If your painting doesn't have enough value contrast, it will read as flat and uninteresting.

COLOR TEMPERATURE

The color wheel is divided into *warm* and *cool* colors.

Warm colors traditionally indicate activity and light and are generally associated with reds, yellows and oranges. Cool colors, on the other hand, indicate calm, distant and soothing environments. Cool colors are typically blues, greens and purples.

I say that these colors are typically associated with their warm or cool category, but each color has many hues that could lead to either side of the color temperature spectrum. Some good examples of this are Ultramarine Blue, Red Shade and Phthalo Blue, Green Shade. You can tell from the names that they have red and green undertones. This means that the Ultramarine will lean more to the warm side and the Phthalo Blue will lean more to the cool side.

Ultramarine Blue, Red Shade

Phthalo Blue, Green Shade

When a warm color is placed next to a cool color, there is a very strong contrast. When a cool color is placed next to another cool color (for example, green next to blue), there is a pleasing, harmonious effect.

White, black and gray are generally considered neutral colors. I get the most use out of these neutral colors by using them not as they are, but rather as modifiers to change the value of my colors. For example, if you have Cadmium Red on your palette, you can add various amounts of gray to make a range of tones.

COLOR COMBINATIONS AND COLOR SCHEMES

There are a number of commonly known color combinations which can be used to evoke certain emotions from the viewer.

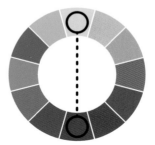

Complementary

Complementary colors are opposite each other on the color wheel. When placed next to each other, there is an extremely strong contrasting and dramatic effect. Complementary colors work well when one is used as a dominant color and the other as an accent.

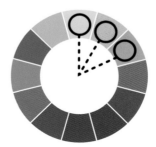

Analogous

This relaxing color combination uses colors positioned next to each other on the color wheel. Analogous color combinations were famously used by impressionist artists such as Claude Monet to create beautiful, harmonious paintings. It is often most effective to select a dominant color, a secondary color and a third accent color.

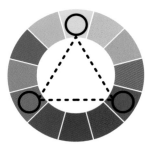

Triadic

A triadic color scheme uses three colors which are evenly placed around the color wheel. The resulting effect is a vibrant scheme, even with low saturation. It is important to properly balance the colors as to not overwhelm the viewer.

COLOR MIXING

When you are mixing your colors on the palette, you can use a brush or a palette knife. I prefer to use my 1-inch (2.5-cm) flat brush to mix my paint rather than a palette knife, but neither one is "better" than the other. When you are mixing with a brush rather than mixing with a palette knife, be careful not to overload your brush and to avoid getting paint into the metal piece at the top of the bristles. You can use a larger brush when mixing larger amounts of paint or, if you're worried about your brush, you can use a palette knife to avoid the mess.

When you're mixing colors, the help you get from the color wheel is limited. The color wheel is based on pure colors and the pigments in acrylic paints are not pure colors. Each color in the tube has a bias toward another color, and sometimes it takes practice to figure out what colors will be best together.

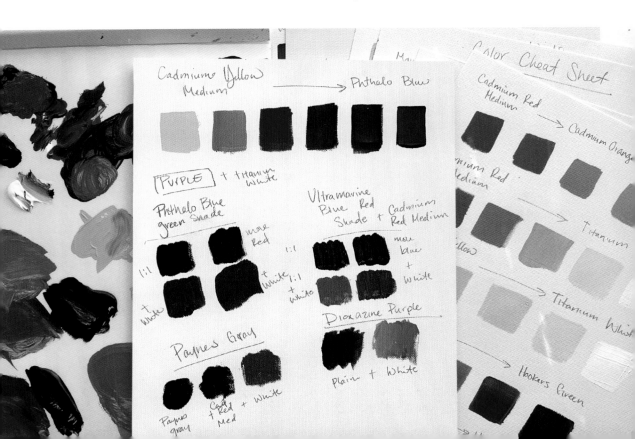

My biggest example of this is mixing purple from scratch. Of course, there is a wide range of colors that you could call "purple," but I'm usually hoping for a vibrant violet color. So, we have established that red and blue mix to create purple, right? That's true in theory. But not every red or blue is created equal, and your paints may not give you the color you're hoping for. When you mix Cadmium Red Medium with Ultramarine Blue, Red Shade, you may end up with a color closer to a muted violet—but if you use Phthalo Blue, Green Shade, the result will be muddy and difficult to read as purple. This happens because Phthalo Blue, Green Shade, has green undertones (a complementary color to red). These colors neutralize each other and the resulting color will be close to gray. In situations like this, I like to go ahead and purchase a tube of purple paint so I don't have to worry about the time it will take to mix the shade I want.

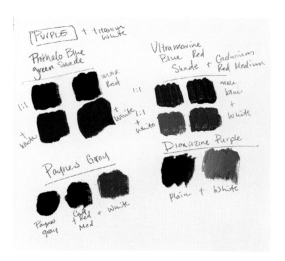

It's not realistic to buy every color that is available to you though, so practicing and studying up on colors will save you some money and even some time going forward. It will certainly save you some frustration.

HOW DIFFERENT COLORS CAN AFFECT THE TEMPERATURE OF THE PAINT YOU MIX

Lightening Your Colors

Mixing white into your colors will not only lighten your color but will also cool it. The white pigment essentially blocks the warmer and darker pigments and may change the overall feeling of your painting if you aren't careful. I often use this to my advantage when I want to desaturate or tone down a color on my palette.

When you are looking for a more vibrant way to change the value of your color, try mixing yellow or another color that is higher in value than the one you want to lighten. For example, adding yellow to green will result in a sunnier, more energetic color than if you use white to lighten the green.

Darkening Your Colors

When you are hoping to darken the value of a color, you can use black, blue or red. Using black will result in a muted and desaturated color. When you use red or blue to darken the color, you will likely produce a color that stands out more and holds its saturation. Stay within your analogous colors when you choose what colors to mix. For example, adding blue to green will deepen the value while remaining in the same color family. If you use complementary colors to darken your colors, the resulting color may not be what you're

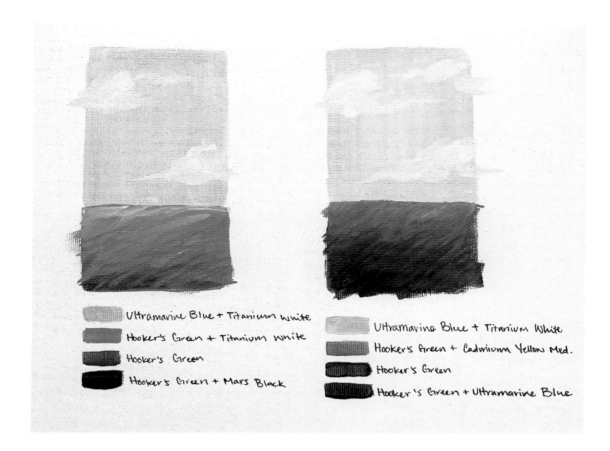

Ultramarine Blue + Titanium White
Hooker's Green + Titanium white
Hooker's Green
Hooker's Green + Mars Black

Ultramarine Blue + Titanium White
Hooker's Green + Cadmium Yellow Med.
Hooker's Green
Hooker's Green + Ultramarine Blue

hoping for. For example, using red to deepen your green will shift the final color to a muddy and earthy hue.

Mixing Complementary Colors

When complementary colors are used separately, they intensify each other. However, when they are mixed together, they neutralize each other. Let's use green and red as an example: when mixed together, they create deep, earthy tones. When white is added to the mixture, they turn into some very beautiful grays. This is great when you want muted or earthy tones but not so great when you are trying to mix vibrant colors.

PERSPECTIVE

Perspective is an art technique for creating an illusion of three dimensions on a flat, two-dimensional surface. Perspective is what makes a painting seem to have form and depth and look "real."

Your brain fills in a lot of information for you without you having to think about it. As you go through life, your mind constantly stores information about the world around you, including depth and perspective. As you draw and paint things in perspective, you might need to check the perspective of your painting often and fix mistakes as they come. Luckily, it's a lot like

color mixing. You have to pay a lot of attention to it in the beginning, but it starts to become second nature as you put it into practice.

TYPES OF PERSPECTIVE

There are many types of perspective used by artists to convey a sense of space within the composition of a work. There is a fair bit of terminology used in perspective, and if you try to take it in all at once, it can seem overwhelming. In this book, I focus on compositions with relatively simple perspective and only touch on a handful of types.

Linear Perspective

The guiding principle for this technique is that objects that are closer to the viewer appear to be larger, while objects that are further away appear to be smaller. To achieve this effect, you need three essential components: orthogonals (also known as parallel lines), the vanishing point and the horizon line.

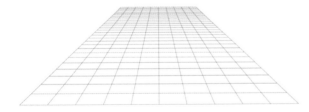

Early Summer Pasture (on page 155) uses linear perspective to give depth to the road and the fence line.

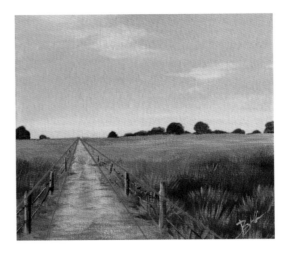

One Point Perspective

One point perspective contains one vanishing point along the horizon line. This type of perspective can easily be used to portray things such as railroads, hallways or room interiors.

Look Up through the Trees (page 67) also features linear perspective but from a different vantage point. All the trees point to one vanishing point in the sky.

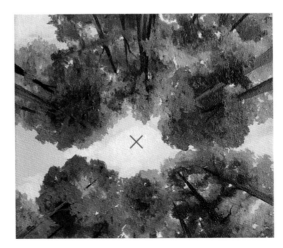

Aerial or Atmospheric Perspective

As well as using lines to create the impression of three-dimensional space on a two-dimensional surface, artists use other techniques to create the illusion of depth in a painting. Aerial perspective or atmospheric perspective refers to the effect that the atmosphere has on the appearance of things when they are looked at from a distance. Instead of using horizon lines and vanishing points, atmospheric perspective primarily uses color. Essentially, objects that are further away have blurry edges and appear lighter in color.

The further away something is from you, the less clear its details are and the less tonal contrast it has (the contrast between lights and darks). Colors also become less bright the further away they are and blend more into the background color of the atmosphere—which is blue (unless there is a sunset, when it is red!). This applies even when the background is not a sky.

In this book, I use a mist effect not only to mimic mist, but to show atmospheric perspective. In Spring in the Mountains (page 83, shown below), the mountains that are farthest from the viewer have a blue hue as well as a layer of fog over them, giving the illusion of depth.

PERSPECTIVE ON CURVES

So far, we have looked at straight lines in perspective—but what about curves? In a landscape painting, you will encounter rounded objects such as roads, streams and bodies of water. These things are a little more difficult to draw in perspective than straight edges.

To help you visualize this concept, hold a coin in your hand with the flat surface facing your eye, then slowly turn it so the flat side of the coin faces up toward the ceiling. It becomes more and more elliptical, the side curves becoming more and more pointy.

This also happens in nature. The closer you are to the ground, the more pointy or elliptical a bend in a road or river or the curve of a bay appears (so often we see a painting spoiled by a bay of water that appears to "stand up" and not "lay" properly in the landscape.) Large rounded curves belong with a bird's eye view.

A few projects in this book follow this rule of perspective on curves. Road Trip through the Mountains (page 87, shown below) features a road curving off into the distance, and Mountain Reservoir (page 137) features the edge of a body of water curving into an outcropping.

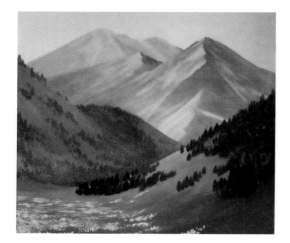

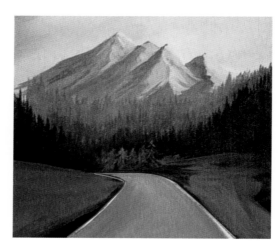

ACRYLIC PAINTING TECHNIQUES

There are many different acrylic painting techniques that you can practice and utilize in your paintings. In this book I will only cover a handful.

- *Wet on wet*
- *Wet on dry*
- *Dry brushing*
- *Splattering*
- *Dabbing*
- *Mist technique*

WET ON WET

This technique involves applying your acrylics to a layer of paint that is already wet. This is a good way to blend colors quickly, but you must work fast because the acrylics will dry before you know it. If you find that your paints are drying before you are done, you can mist your painting with some water or add a little more water to your brush as you apply paint. If your paint is starting to feel gummy or is starting to lift off the canvas instead of spread, it would be better to stop blending and wait for the paint to dry.

WET ON DRY

The wet-on-dry technique is used when you apply wet paint to a dry surface. Because the first layer is dry, this allows for more controlled brushstrokes and crisp lines. Once your first layer of paint has dried, you can apply thick or thin layers of paint on top without worrying about the colors blending or muddying.

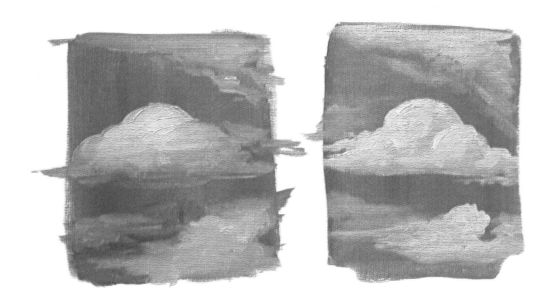

DRY BRUSHING

Dry brushing is a technique in which you apply paint to a dry brush, wipe off the excess and apply very light strokes to your canvas. This helps to add subtle highlights, textures and specific details to your painting.

I most often use this technique when painting fog to create little tendrils and controlled coverage on a smaller scale.

Step 1

Test your brushstrokes before applying them to your painting. I like to do this to check the amount of paint that I have on my brush. If you have too much paint, your brushstroke will be too opaque, and if you don't have enough paint on your brush, it will not show up on the painting. You can test your brushstrokes on a scrap piece of paper or in a place on your painting that you can easily cover up if you don't like the outcome.

Step 2

Load your paintbrush with the desired paint with a small amount of water mixed in.

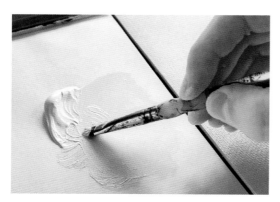

Step 3

Wipe the excess paint off your brush and onto a towel.

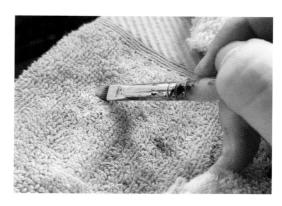

Step 4

Very gently drag the brush across the surface to transfer small amounts of paint to the painting. Using only a small amount of paint allows the texture of the canvas to break up the brushstroke and create the illusion of texture in the painting. In this example, I am painting mist, something that is suspended in air and is not a solid object. I want some of the tree behind the fog to show through.

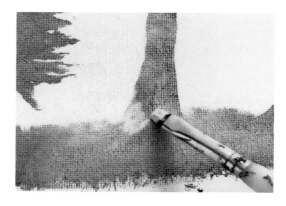

Different brushes will have different effects. A soft, fluffy brush will give you light and airy results, while a stiffer brush will give you more precise strokes.

SPLATTERING

Splattering is when you flick paint on the canvas to create little dots or splatters of paint. It can be used for all sorts of environments. You can use it to add water drops flying about at the bottom of a waterfall or for stars in the night sky like in Celestial Sky on page 103. The best method for this, I've found, is to load a stiff brush with a color of your choice that has been thinned down with water. Wipe most of the paint off so no large globs of paint are on the bristles. Hold your brush so the bristles are perpendicular to the canvas and use your other hand to pull the paint-filled bristles back, releasing them quickly so paint flies off the brush and onto the canvas. Hopefully only small dots will appear. If you have some unwanted splatters or lines, wipe them off quickly with a clean wet brush and they should be easily removed.

DABBING

Dabbing is essentially bouncing your paint onto the canvas. This is a great way to add texture and patches of paint to a painting. This technique can be done with brushes or a paper towel to quickly create texture and cover surface area, as in Enchanted Grove on page 41. I also use this technique to create branches of thick pine trees, like in Frosty Pines on page 61.

If you are looking to create texture with this dabbing motion, I recommend using heavy body paint. This paint holds its texture well without added mediums. If you don't have heavy body paint, you can still achieve a bit of texture with your acrylics by loading extra paint onto your brush. Soft body and fluid paints will not hold a texture, though. Their structure lends itself more to smoother applications.

MIST TECHNIQUE

The mist technique is basically just spreading white paint over your painting to create fog. This technique is one of my all-time favorites. I have spent years playing with this and find a way to incorporate it into most of my paintings.

Step 1

Make sure your entire painting is completely dry. I usually wait a full day before using this technique to ensure that the paint has dried all the way through. You may be able to get away with 5 or 6 hours of waiting, but I would test a small section of the painting before spreading fog across the whole painting. This way, if your paint is not dry enough, you can easily paint over it and wait a little longer for the paint to dry fully.

Step 2

Get your Titanium White paint and set a fresh dollop of paint onto your palette. A key part of this technique is using clean tools and fresh paint.

Step 3

Start with a clean, dry cloth about the size of a hand towel or washcloth. The texture of this towel should be soft and absorbent; you do not want any scratchy or rough pieces to interfere with your painting process. Take the cloth and wrap it around the index and middle fingers of your dominant hand, holding the bulk of the cloth against your palm with the rest of your fingers.

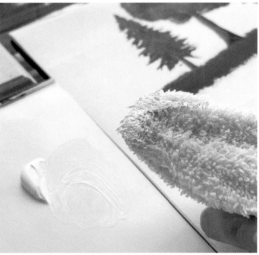

Step 4

Dip the tips of your fingers with the cloth into clean water. The water needs to be clean and not discolored or it will discolor your fog. Dab off the excess water with another towel. This technique works best with a damp cloth and not one that is dripping wet. Then swirl your fingers in the fresh white paint on your palette so there is a small amount of paint saturating the cloth.

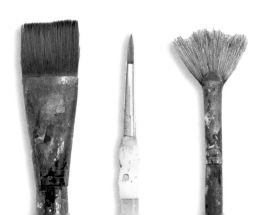

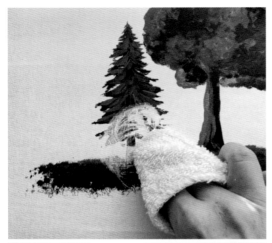

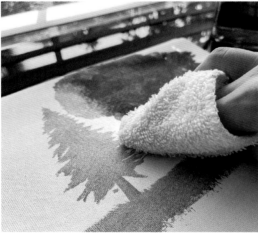

EXERCISES AND PRACTICES TO ADVANCE YOUR SKILLS

Some of the exercises that are the most helpful are also the exercises that seem too tedious to spend time on. Lots of practice feels this way. Why would I spend the time doing something if I don't even get to be good at it the first time around?

Well, you will never be comfortable with your tools if you never use them. Sure, the script liner brush looks scary and seems like it would be unruly. And yet that brush is easily among my top three favorite paintbrushes. It just glides over the canvas and allows me to paint the most delicate details with little struggle. I know this because I use it almost every day. Give it a try.

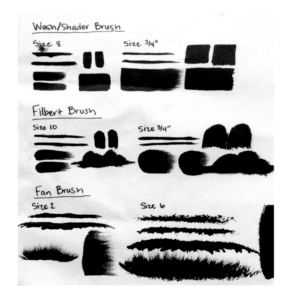

Step 5

Apply the paint to the painting in circular motions and with light pressure. Do not press too hard or it will start to peel the dry paint off the canvas. I find that moving the paint around in multiple directions helps fill in the texture of the canvas for a smoother finish.

Step 6

Apply more white paint to any parts of the fog that look too thin. A clean, damp part of the cloth will help take paint off if any spots are too thick and cover your painting too much.

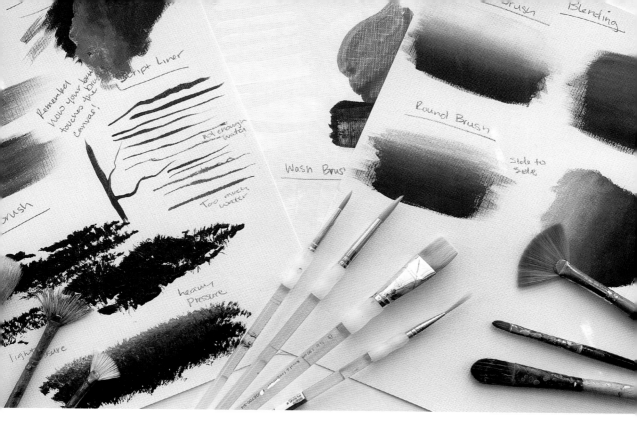

I encourage you to make yourself a cheat sheet. Practice using each brush that you own and play with how much water and paint each one needs to work effectively as well as testing out all the different brushstrokes each one can create. They don't need to be clean and show worthy—these are just for you. Not only will this give you something to refer to when you're painting, it will give you tangible knowledge of how each brush works. You get to hold each brush with your own hands and feel how much pressure to apply and how the bristles fray when you move it a certain way. It can be a beautiful experience, really.

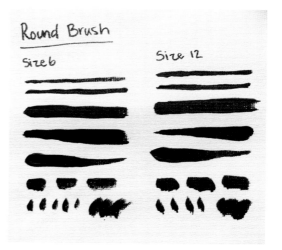

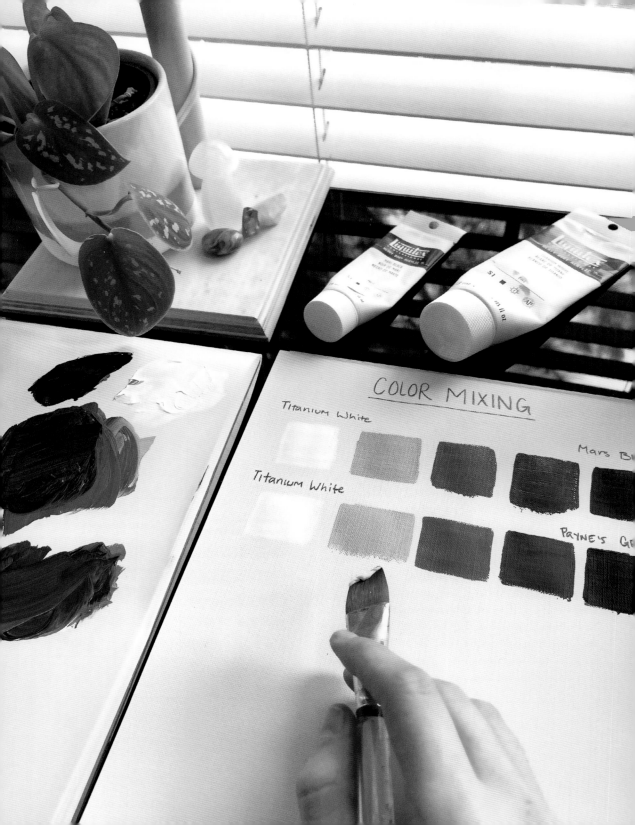

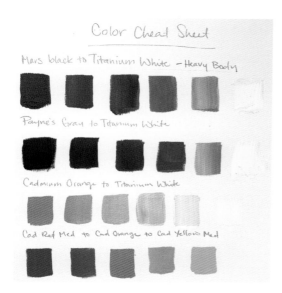

Color Cheat Sheet

Mars black to Titanium White – Heavy Body

Payne's Gray to Titanium White

Cadmium Orange to Titanium White

Cad Red Med to Cad Orange to Cad Yellow Med

You should also practice mixing your colors and testing how each one dries, seeing how each one mixes with white and black and simply feeling out how to control the amount of paint you add when mixing colors.

Practicing your new skills and studying different techniques is important, but painting is so much more than what your trees look like or how well you blend your paints. Painting activates your soul and draws you into another version of the world that is filled with color and texture. So many of us go through life without noticing the incredible beauty that everything holds. When you pick up painting, something within you changes. I often find myself staring at the sky trying to absorb all the colors, the softness of the clouds, the way the sun rays spill out onto the world.

Sometimes, though, inspiration does not come easily, and it can be difficult when artist's block hits.

Everyone hits a wall at some point in their painting process. Whether it's because you're feeling uninspired or because you've just spent two hours painting the same thing over and over, it is completely valid. I have a few things for you to try when you hit that wall.

Take a break and leave the room. In class, my students like to take a bathroom break when they feel like pulling their hair out. This really helps because when they come back, they see their painting with fresh eyes.

Look at your artwork from a different perspective. You can turn your painting upside down, take a photo and invert it, even step back and look at it from further away. When you look at something long enough, your brain starts to blur the details and you get a little lost.

Check out your values. This trick also shows our painting from a different perspective, but in a different way. Take a photo of your artwork and turn the saturation down to zero. This removes the color and reveals the values that make up your painting. If the grayscale version of your painting reads flat, your painting does too.

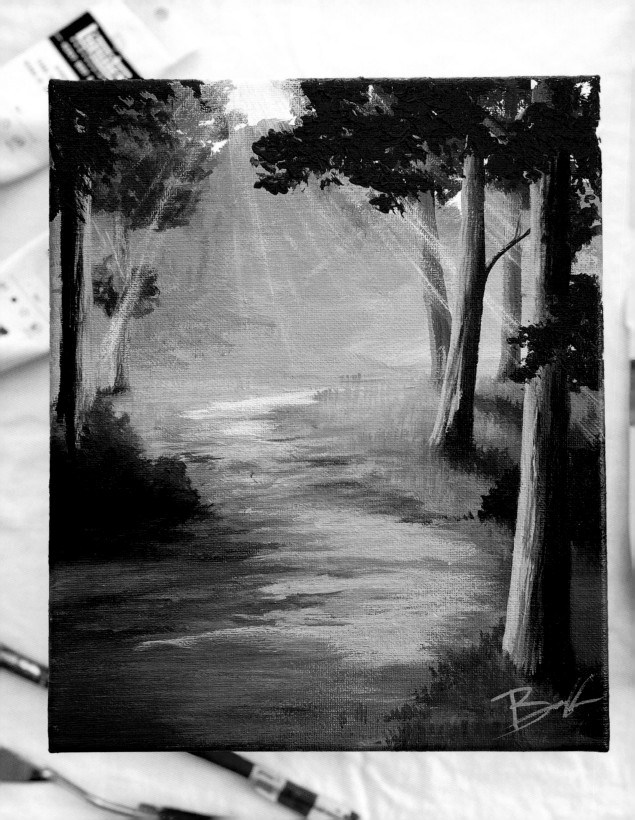

JOURNEY THROUGH THE TREES

"Between every two pines is a doorway to a new world."
-JOHN MUIR

In this chapter, we will explore different ways to depict trees and woodland scenes. We get to play with perspective and mood with each of the settings in this chapter. I am very excited for you to learn all the different techniques and brushstrokes so you can build your own forest.

There is something so beautiful about how imperfect and unique trees are. Painting them is truly a blessing. Nature lends itself to the process of soulful painting. You can let go of perfection while capturing the world around you as you see it.

While there are some simple guidelines for painting trees, you should not feel so pressured to follow the rules that painting becomes stressful. You will encounter a time when your brush leaves an unexpected mark or your lines are crooked. This is the perfect opportunity to embrace those little accidents and watch each imperfect tree add to the forest around it. You can pour yourself into these forests and express how you feel or what you need and still leave it up to the painting to reveal things that you didn't know were there.

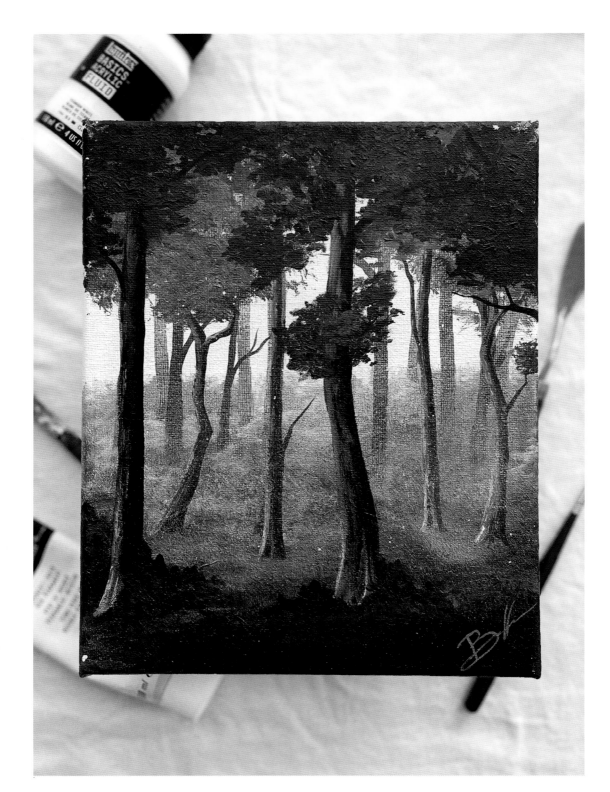

ENCHANTED GROVE

This project is an example of using real life to make a world of your own. I have been in misty forests before, but I have yet to experience one just like this. Imagine walking through the spindly trees and feeling the fog touch your fingertips.

This painting really allows you to practice controlling the script liner paintbrush. This brush is one of my absolute favorites but may be intimidating to those who haven't used it before. With a little practice, it gives you the ability to create thin and precise strokes that would otherwise be much more difficult. I also love to utilize the stiff texture of the boar hair bristle fan brush when creating grass and leaves. I find it to be much faster than individually placing down each blade of grass and leaf on the branches with a small brush.

MATERIALS LIST

8 x 10" (20 x 25 cm) canvas
Acrylic paint
 - *Hooker's Green Hue*
 - *Mars Black*
 - *Titanium White*
Paint brushes
 - *#8 boar hair fan brush*
 - *#2 script liner brush*
 - *#3 round brush*
Palette
Cloth (towel or microfiber cloth)
Clean water

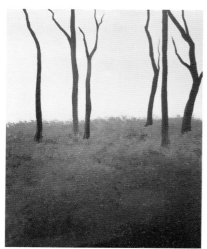

1

STEP 1: To start this painting, mix a dark green by adding equal parts Hooker's Green and Mars Black for the grass. Load your #8 fan brush with this dark green and fill the bottom half of the canvas. While the paint is still wet, pick up some Titanium White with your fan brush and dab along the horizon line. Dab your brush horizontally across the canvas, stamping your paint onto the surface as you go (refer to the technique on page 32 if needed). As you move the brush around the canvas, it should start to blend the white into a lighter green that transitions to the existing dark green.

(continued)

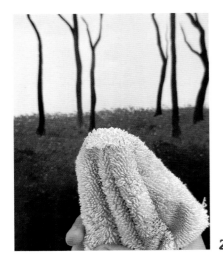

2A

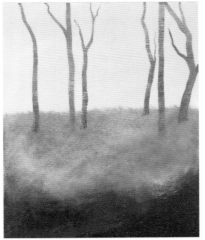

2B

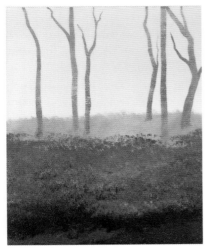

3

Once the paint has dried enough to paint over, load your script liner brush with Mars Black and create some spindly trees with the trunks starting just under the horizon. It is okay if your brush picks up some paint from the previous layer; this group of trees does not need to be perfect, as they will have several layers of fog covering them by the end of the project.

STEP 2: Wait for the paint to dry completely. The grass layer that was applied with the fan brush will take the longest to dry, and you may need to wait longer than you think.

After the paint has dried for 4 or more hours, cover the entire top portion with a layer of fog (refer to page 32 if needed). Focus the fog coverage on the sky, tree line and top section of the grass. Don't worry about making the fog layer completely even; swirls of more or less fog only add to the scene.

STEP 3: In this next layer, use the same technique of blending on the canvas as you did with the first layer of grass. Start with the same dark green that you used in Step 1 and tap across the bottom of the canvas with your fan brush. This blanket of grass should end just underneath the trees you just painted. Add a dab of Titanium White to your brush and move it across the canvas, blending the white into a light green along the top half of the fresh layer of dark green.

STEP 4: Paint some more thin trees with the Mars Black and your script liner brush. Space them out enough that you don't cover the trees that you painted in the first layer, and stagger the bottoms of the tree trunks so they're not too uniformly spaced. Using your dark green mixture and your fan brush, dab some leaves onto the tops of the trees, making sure not to cover up everything that you've worked hard on.

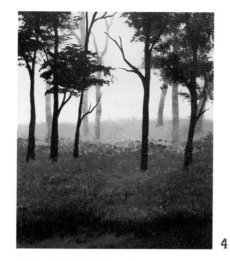

4

STEP 5: Wait for this layer to dry completely and add another layer of fog, covering the entire painting. Don't worry about streaks or thin spots; fog is unpredictable and curls as it flows through the air.

STEP 6: The thin layer of fog will most likely dry before you have a chance to add anything else. But, on the off chance that it is still wet, wait for it to dry before moving on. Once dry add another layer of grass with a dark green on your fan brush. Add white the same way you did in the previous layers to blend into a lighter green near the top. Pull the grass up to the base of your trees but do not cover them. Add some more spindly trees with your script liner and continue spacing them so you can still see the trees behind them. Mix a gray color with equal parts Titanium White and Mars Black, and load your round brush. With your round brush, drag the gray up the tree trunks. Use the canvas texture to your advantage when adding this highlight so it looks like your trees are covered in bark. This is the second to last layer, so you will be able to see these details at the end.

Add a scattered layer of leaves across the top of the canvas and over the tops of the trees with the dark green on your fan brush. With this same brush, dab the dark green along the grass and bring it up to the bottoms of the tree trunks, but do not cover them.

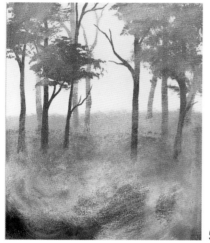

5

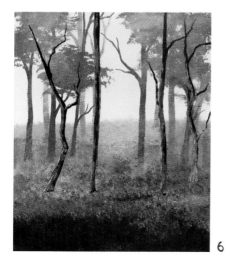

6 A

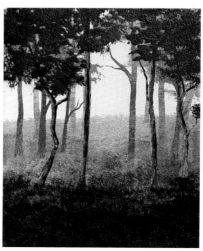

6 B

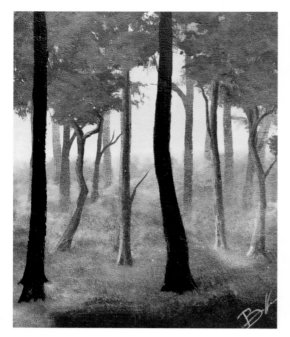

7

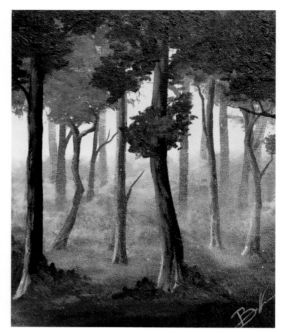

8

STEP 7: Once the layer of paint is completely dry, add a much thinner layer of fog to the entire painting. You still want to be able to see the detail in your most recent layer of trees. As you are working with the fog, dry brush some small wisps of fog among the trees and along the horizon line to add a little bit of mystery. To do this, take a clean, dry #3 round brush and load it with Titanium White. On a clean cloth, wipe off as much paint as you can without cleaning it off completely. Gently rub the paint that is left on your brush onto the canvas where you want the wisps to curl through the trees. If there's too much paint, you can dab it with your finger and it will help it look a little more like fog.

Pick up some Mars Black paint on your round brush and create two thicker tree trunks. Place these trees in any spots that feel blank or open.

The base of the trunk is lower on the canvas than the trees before it and these trees have the thickest trunks because they are the closest to the viewer.

STEP 8: Paint some delicate branches with your script liner and Mars Black. Use the gray from Step 6 to add highlights and texture to these trees with your round brush.

Use your fan brush and dab some leaves onto the tops of the trees and around the branches with some dark green. You can also add more texture to the ground by using your round brush to dab some dark green around the base of the trees and along the bottom of the canvas to create some taller foliage on the forest floor.

Make sure to sign your painting when you are done!

WOODLAND PATH

When I imagine walking down this path, I feel a touch of warmth on my skin and the joy of the sunlight filtering through the trees. The bright and saturated colors of this painting bring it to life and invite a rather happy feeling in the viewer.

This painting builds on the previous project by taking techniques you practiced, like creating leaves and tree trunks, and introducing more color for a different mood overall. In addition to adding colors, this is the first painting in the book to feature a road in perspective as it winds through the trees and across the ground.

MATERIALS LIST

8 x 10" (21 x 26–cm) canvas
Acrylic Paint
- Hooker's Green Hue
- Titanium White
- Mars Black
- Raw Sienna
- Burnt Umber
- Cadmium Yellow Medium

Paintbrushes
- 1" (2.5-cm) flat brush
- #2 boar hair fan brush
- #2 script liner brush
- #4 round brush

Palette
Towel or microfiber cloth
Clean water

1

STEP 1: Fill the bottom of the canvas with a light green consisting of equal parts Hooker's Green and Titanium White paint. Use your flat brush to cover the surface and then to block out the path in the wet paint. This is just to help you plan ahead for the composition of the painting.

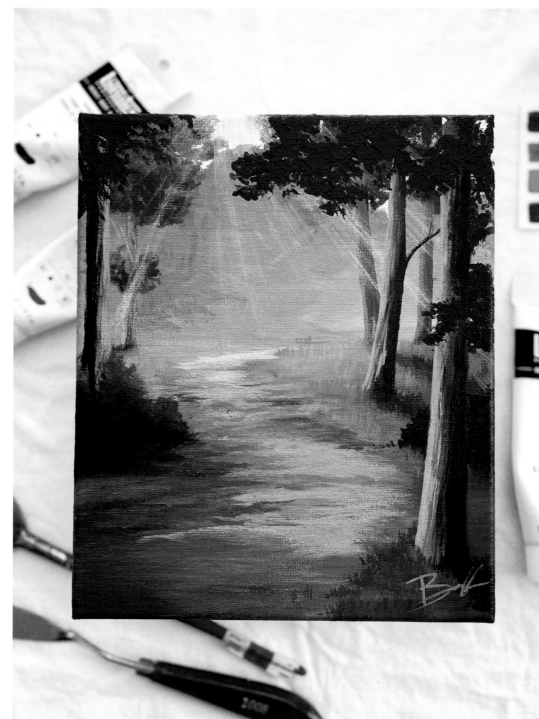

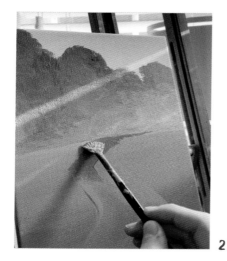

2A

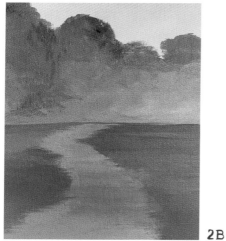

2B

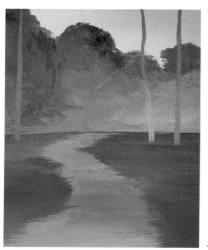

3

STEP 2: Once the paint is dry, take the light green from the first step and add a touch of Mars Black to desaturate the color. Create a tree line above the horizon with your flat brush and keep the brushstrokes loose, using circular motions to make them look fluffy. Add a small amount of Titanium White to your brush and apply this to the wet green trees toward the horizon line.

Cover the ground on either side of the path with the same desaturated light green using your flat brush. Next, mix up the color for the path using Raw Sienna and just a dash of both Mars Black and Titanium White. Use your #2 fan brush to paint the path that you mapped out in Step 1. Use horizontal strokes while holding your fan brush perpendicular to the canvas for this step. This technique begins to add texture to the packed dirt that makes up the path.

STEP 3: Once the paint is dry, start mapping out the tree placement by using your script liner brush to paint a guide for the three trees that are farthest back in the painting with a light brown of equal parts Titanium White and Raw Sienna.

Once you are happy with the placement, start filling out your trees using your script liner brush. Use a dark brown to thicken up the tree trunks and a lighter brown to add highlights. For the dark brown, mix equal parts Raw Sienna and Burnt Umber with just a dot of Mars Black. Paint in a few small branches toward the top of each tree. For the highlights on the trees, take some of the dark brown you mixed and add some Titanium White to lighten the color. Once the dark brown is dry, use your script liner to add highlights to the left sides of the trees.

Now it's time to paint some foliage. To create the leaves in the trees, use your round brush to dab a dark green around the tops of the trees and around the branches (refer to page 32 if needed). This green is made with Hooker's Green and a bit of Cadmium Yellow Medium. (I used a round brush in this step rather than a fan brush because the leaves on these trees are soft and round; the fan brush often leaves the foliage looking sharper and more textured than I wanted in this painting.)

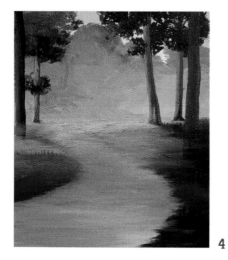

4

STEP 4: Once your leaves are done and your paint is dry, start to map out the next layer of trees. Use your round brush and the dark brown paint to add two trees to the outer edges of the image. These trees will be thicker because they are closer to the viewer.

Toward the horizon line, use your round brush to add some yellow-green where the sun hits the ground. This color is primarily Cadmium Yellow Medium with a small amount of Hooker's Green. Don't worry about going over the second layer of trees a bit; we will fix that later.

Since we have established the highlights in the grass, add some highlights to the path to match. Take the same color used on the path and mix in a bit of Titanium White paint. Apply this mixture with horizontal brushstrokes to add highlights to the path where it meets the horizon and in a few places down the path. This layer does not need to be perfectly placed as we will be adding more depth later on in the painting.

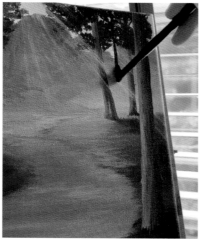

5A

STEP 5: Drybrush some sun rays coming in from a break in the trees using your dry, clean fan brush to pick up some Titanium White. Wipe most of the paint off on a towel before using it, and then very gently stroke the bristles across the canvas, pushing just enough for a little paint to transfer onto the scene.

After you have added your sunrays, finish the trees you started mapping out in the last step by fully filling out the trunks with your round brush loaded with dark brown.

This is also a great time to add any details that you feel would add to the landscape. I felt as though there was a gap on the right side of the composition, so I included another tree that I hadn't planned for in the previous step.

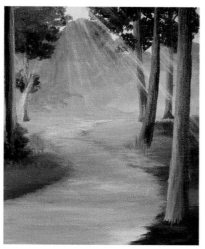

5B

Use your round brush to adjust the highlights in the grass and path to extend out from where the sun is brightest. The shadows should fall behind the trees and leave the top of the path as the brightest spot on the ground. Use your script liner brush to create short, vertical strokes in the grass for some added texture along the forest floor and your round brush to add some foliage around the base of the tree on the left side of the canvas.

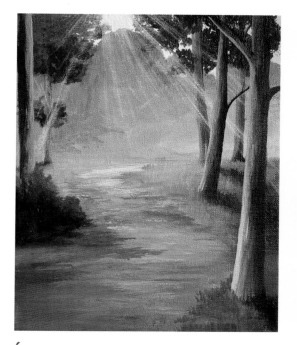

6

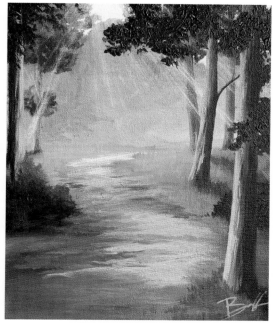

7

STEP 6: Add a few branches at the top of the trees on the right-hand side using your script liner and the dark brown used to paint the tree trunks. Once the dark brown is dry, add a highlight along the side of each tree that is facing the sun. This highlight is the same color used in Step 3 to highlight the first layer of trees. For the trees on the left-hand side of the painting, the highlight will be on the right side of the trunks, and for the trees on the right-hand side of the painting, the highlight will be on the left side of the trunks.

Add texture and interest to the forest floor by dragging green into the path. If you want to add extra depth to the path, feel free to add some shadows. To do so, load your fan brush with Raw Sienna and use horizontal strokes to subtly darken the bottom left-hand corner and any other areas the sunlight misses. Further define the shadows behind the trees with little vertical brushstrokes for blades of grass, deepening the shadows and lightening the highlights.

STEP 7: To finish this painting, load your fan brush with the dark green from Step 3 and dab some leaves across the top of each tree close to the viewer. I like to add some extra texture in the final layers of my paintings. In this piece, I am using a heavy body paint that holds its texture quite well. If you don't have heavy body paint, load your brush with extra paint. Add any other foliage or detail to the forest floor that feels interesting to you. I added some bushes to the ground on the right side of the composition and some more leaves to the tree above it.

Add the lightest highlights on the path in the center. This is where the sun is most likely to hit the path. For these final highlights, mix a light brown with one part Raw Sienna and two parts Titanium White and apply it with your fan brush using short horizontal strokes. Once your painting is dry and the sunshine has filled the landscape how you want it to, remember to sign your work. You made that! Own it.

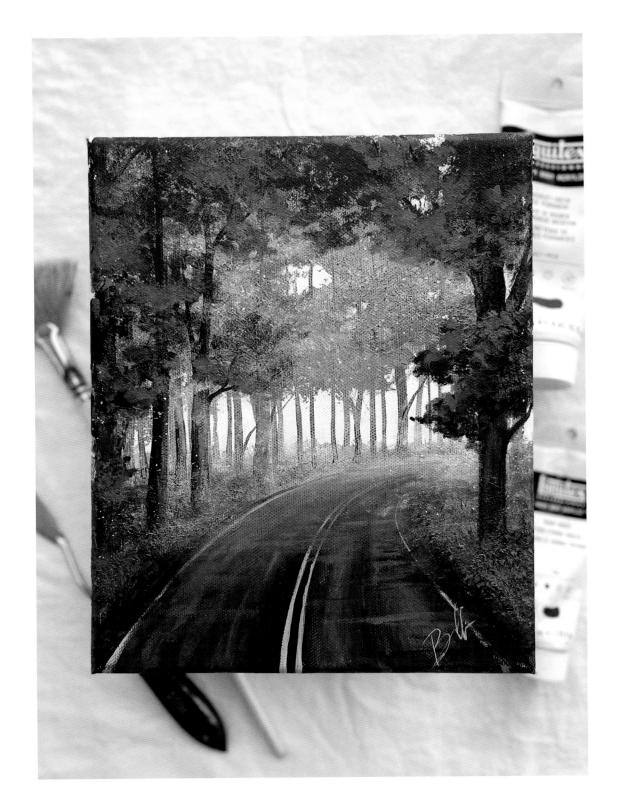

FOGGY FOREST ROAD

I am so excited for you to paint one of my most beloved landscape scenes. Whether I am able to drive through a foggy forest on a road like this or I simply have the pleasure of painting it, I find so much peace in the view. I hope you are able to slow down and feel content throughout the painting process while we create this road winding through the trees.

Another reason I love this project is that it includes so many of my favorite techniques. Everything from using the fan brush to quickly create grass and leaves, to using the script liner brush to glide across the canvas to make tree branches, to covering each layer with fog to build depth into the image.

MATERIALS LIST

8 x 10" (21 x 26–cm) canvas
Pencil
Acrylic Paint
* *Titanium White*
* *Mars Black*
* *Hooker's Green Hue*
* *Burnt Umber*
* *Cadmium Yellow Medium*

Paintbrushes
* *1" (2.5-cm) flat brush*
* *#3 round brush*
* *#2 boar hair fan brush*
* *#2 script liner brush*

Palette
Towel or microfiber cloth
Clean water

1

STEP 1: Use your flat brush to cover the entirety of the canvas with a wash of Titanium White paint. This will allow your paint to cover the canvas smoothly and give you a wet surface to begin the painting with.

2

STEP 2: Mix a medium gray color with two parts Mars Black and one part Titanium White. While the white is still wet, load a round brush with this newly mixed color and draw a line across the canvas roughly one-third from the bottom. Using this line as a guide, use your loaded round brush to draw a line from the bottom left corner of the canvas that curves up to end just under your first line on the right side of the canvas. This defines the left edge of the road. To draw the right side of the road, begin on the bottom right corner of the canvas, curve inward toward the center of the canvas and end the line on the right side of the painting surface just under your previous lines (refer back to page 27 for perspective help). Once you are happy with the outline of the road, fill in the shape with the round brush or your flat brush to establish the placement.

STEP 3: Once the paint is dry, load your fan brush with Hooker's Green and fill in the two white spaces next to the road. This will create the ground and the foundation for the forest. You can use a dabbing motion to create the texture of grass (refer to page 32 if needed).

STEP 4: Load your script liner brush with watered-down Mars Black paint and line the horizon with thin trees. Evenly space them across the canvas, but make sure to add some variety when deciding on how to space them out.

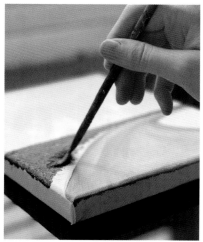

3A

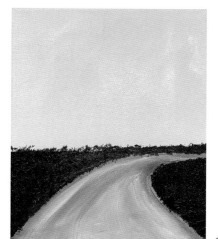

3B

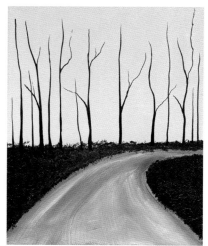

4

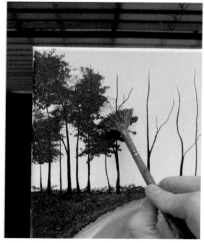

5 A

Clump some together and allow there to be a lone tree every now and then. Each tree should have less than two branches to leave empty space for trees later on in the painting process.

STEP 5: Once the trees are dry, use the same technique you used for the grass, load your fan brush with Hooker's Green paint and dab some leaves onto the trees. Try using the corner of the fan brush in the beginning so you don't cover too much of the background too quickly. Each tree should receive some leaves but not so many that you lose sight of the tree trunk underneath. Leave some white spaces as well—this helps the painting to look more realistic.

STEP 6: Wait for the painting to dry completely. This is the part of the painting that tests my patience the most! The next step to this painting will agitate the paint on the canvas and, if it is not completely dry, green and black will be spread across the canvas and make a muddy mess. I like to wait between 5 hours and 24 hours.

Once the paint is dry, add some fog across the whole canvas (refer to page 32 if needed). Don't worry about having completely even coverage! Fog naturally varies and is not perfectly constant.

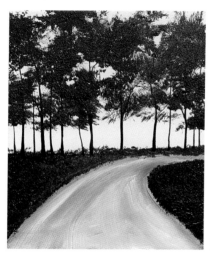

5 B

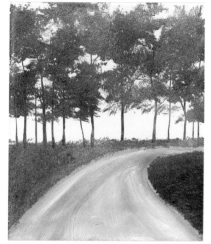

6

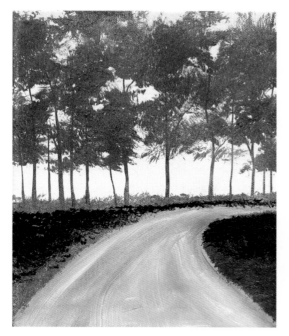

7

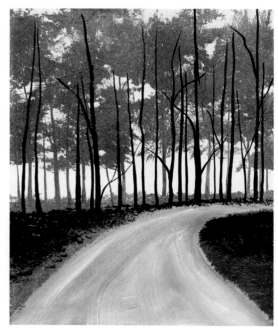

8

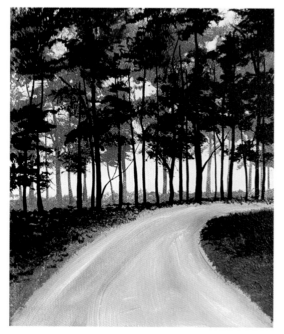

9

STEP 7: This is where we begin repeating techniques. After you have covered the previous layers with fog, mix a dark green with Hooker's Green and a drop of Mars Black. Load your fan brush with paint and dab your brush over the grass to build up the forest floor. Do not cover the entirety of the previous green—you want to leave some of the prior layer visible at the horizon line and along the edge of the road. This will help to blend this layer and the original layer of grass smoothly.

STEP 8: After you have your new layer of grass established and the paint is dry, add another line of tree trunks across the canvas. Because the trunks of these trees are closer to the viewer, they need to be lower on the canvas to create the illusion of space between the newer and older trees. Using your script liner brush and Mars Black paint, draw the slender trees and allow them to overlap the previous set of trees slightly. Try not to cover up all your work!

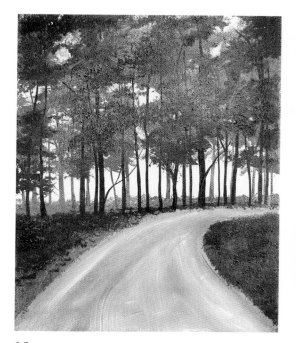

10

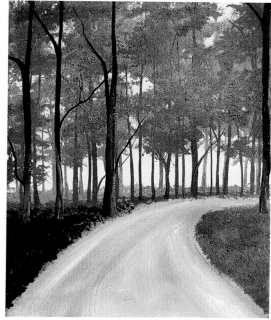

11

STEP 9: Let the previous step dry for a bit before loading your fan brush with Hooker's Green paint and a bit of Mars Black to block out the leaves for this set of trees. Repeat Step 5, remembering not to completely cover the white space beyond or the leaves in the background.

STEP 10: After waiting for the leaves to dry completely, cover the new paint with a layer of fog (refer to page 32 if needed). Do not worry about a completely even coverage while you are creating this layer of fog. I find that the varying thickness of fog helps to create depth and texture!

STEP 11: During this next step, focus more on the left side of the painting than on the right. Start by filling in the left side of the grass with the same fan brush and darkened Hooker's Green paint from Step 9. Make sure to scatter a few dabs of grass along the top to help it fade into the previous layers. Once we have our grass blocked out, it's time to paint a few trees! These trees will be quite a bit larger than the previous ones and will feature a highlight along the base. Load your script liner brush with a mixture of Mars Black and Burnt Umber to create the base color of the trees.

Once the tree placement is decided, mix a light gray with Mars Black and Titanium White. This will be the color you use to add highlights to the trunks of the trees. I like to add the highlight while the dark tree trunk is still wet so the colors blend slightly.

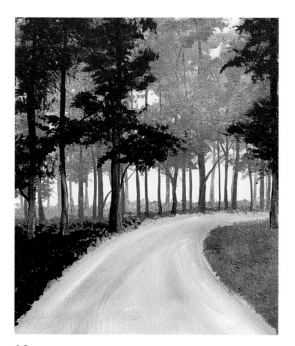

12

13

STEP 12: Let the trees dry before, once again, loading your fan brush with Hooker's Green and a drop of Mars Black. Using the corner of your fan brush, start to block out the leaves for the newest layer of trees. This application of green for the leaves needs to be more open and scattered than the previous layers because there are fewer trees to fill up the space. Do not go all the way across the canvas; allow there to be a space in the middle.

STEP 13: After waiting for the paint to dry completely, apply another layer of fog evenly across the entire painting (refer to page 32 if needed).

STEP 14: In this step we will be darkening the road and beginning the last section of grass. Mix Mars Black, Titanium White and Burnt Umber to create a medium tone for the base of the road. Using your flat brush, cover the middle section of the road with brushstrokes that follow the flow of the road. Avoid using vertical or horizontal strokes as they will cause the road to look flat and without depth. While the paint is still wet, mix a darker tone with the same colors but less white and cover the bottom of the road. Blend the two tones with brushstrokes that follow the curve of the road.

Before moving to the next step, apply a thin layer of grass to the bottommost part of the canvas using your fan brush and Hooker's Green paint. Dab the green into the grass along the side of the road, concentrating your strokes at the bottom of the canvas.

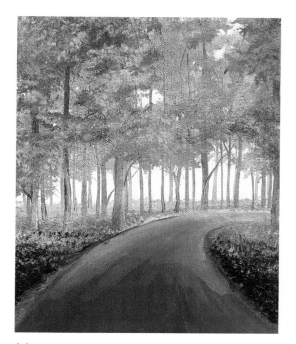

14

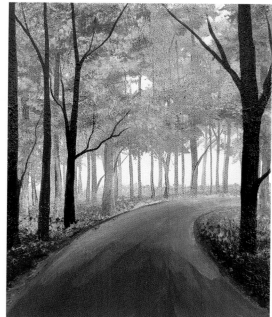

15A

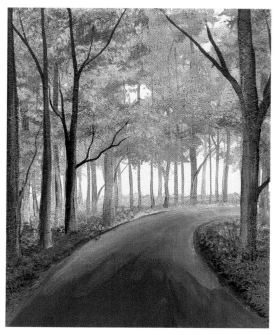

15B

STEP 15: We are now painting our last group of trees! These will be the largest and the most visible in the painting. Don't worry, though. They do not have to be perfect. Create the trunks of the trees with a mixture of Mars Black and Burnt Umber. I like to use my round brush for the thicker tree trunks and my script liner brush for the branches and twigs. Once you are comfortable with the shape and the placement of the trees, mix a lighter paint color for the highlights in the tree bark. I use a mixture of Burnt Umber and Titanium White with a small drop of Mars Black. Utilize the texture on the canvas and use your round brush to loosely fill in the tree trunks with this brown. Do not feel like you need to blend these colors smoothly, as trees are naturally rough and have their own varying colors.

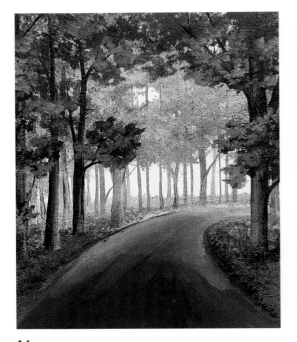

16

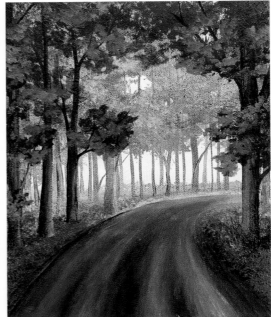

17

STEP 16: Being careful not to completely cover your newly painted trees, use your fan brush to block in the leaves with the darkened Hooker's Green. At this stage it may be helpful to use your round brush to add individual clumps of leaves around the edges. I like to add a lighter green while the paint is still wet to add some highlights to the leaves as well as the grass. This green is made by mixing one part Titanium White with two parts Hooker's Green paint.

STEP 17: Now it's time to add the details to the road! When you look at a road that has been well used, you will find signs of wear that add interest and texture to the pavement. Mix two shades of the color you used to fill in the road. The highlight shade is made with two parts Titanium White and one part each of Mars Black and Burnt Umber. The darker shade is mixed with one part Titanium White and two parts each of Mars Black and Burnt Umber. With the lighter-toned paint, plan out where you want to add the wear created by the cars that pass through. These lines follow the direction of the road and are wider toward the bottom of the canvas, tapering as they get further back. Once you feel good about the placement, use a round or flat brush loaded with the darker tone to blend the edges of the light paint to create a gradient on each side of the tire-worn road.

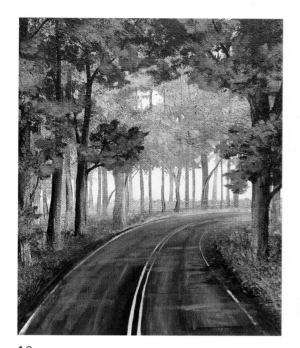

18

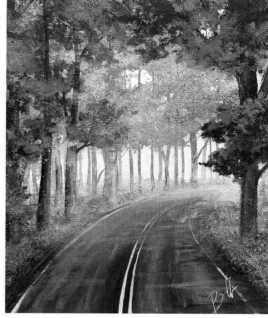

19

STEP 18: To create the lines on the road we will need two colors. The "white" lines on the sides of the road are actually a light gray-brown. To make this color, mix together Titanium White and small amounts of Mars Black and Burnt Umber. The lane-divider lines in the middle of the road are created with this same combination of colors but with a dab of Cadmium Yellow Medium also mixed in. Using your script liner brush, carefully and lightly trace the sides of the road with the "white" and the two lines in the center of the road with the "yellow."

Now this next stage of painting the road is optional. You can keep the road relatively smooth if you prefer or you can add uneven horizontal lines across it to make the road look even more worn down. To create this effect, use the light and dark colors of the road from Step 14 and paint horizontal lines lightly across the road with your round brush.

STEP 19: To finish off this painting, add some small white dots into the fog with the very tip of your script liner brush. Load your brush with Titanium White and very lightly touch the canvas with the tip of your brush. You can use the dry brushing method (refer to page 31 if needed) to add a little bit more mist to the furthest curve of the road and to the trees in the center of the canvas. As always, don't forget to sign your artwork! Be proud of what you have created!

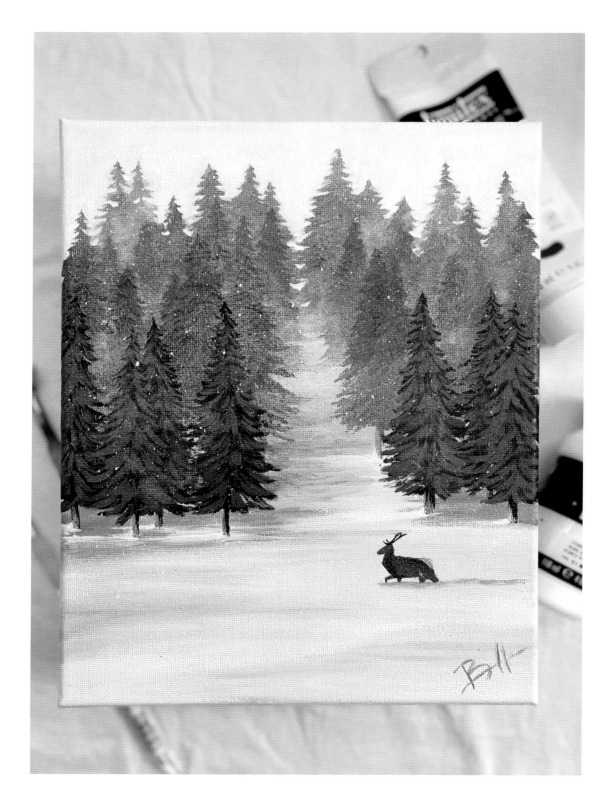

FROSTY PINES

Snowy landscapes have a certain type of magic to them. Something about the way the snow blankets the ground and snowflakes fall softly through the air makes everything feel enchanted. Everything sparkles with fresh little ice crystals and the air is crisp and new.

In this painting we will be using my favorite fog technique over my favorite type of tree. Each layer of fog pushes the evergreen trees back into the snowy distance, adding a unique kind of depth. The limited color palette is perfect for creating a peaceful environment and a simple yet powerful composition.

MATERIALS LIST

8 x 10" (21 x 26–cm) canvas
Acrylic Paint
- *Titanium White*
- *Mars Black*
- *Hooker's Green Hue*
- *Burnt Umber*
- *Raw Sienna*

Paintbrushes
- *1" (2.5-cm) flat brush*
- *#8 boar hair fan brush*
- *#2 script liner brush*
- *#2 boar hair fan brush*
- *#4 round brush*

Palette
Towel or microfiber cloth
Clean water

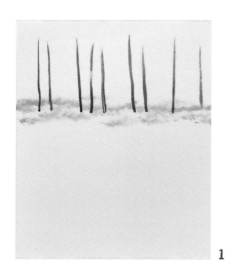

1

STEP 1: Start by priming your canvas with a layer of Titanium White paint using your flat brush. While the paint is still wet, load your #8 fan brush with a light gray made of two parts Titanium White and one part Mars Black. Gently dab the tips of the bristles onto the canvas about a third of the way down from the top. This marks where your first layer of trees will stand. Once all the paint is dry, fully saturate your script liner brush with Mars Black paint and paint some vertical lines onto the canvas. I am using soft body paint, but if you don't have any, simply add a bit of water to the black on your palette to thin out the paint enough to run smoothly over your canvas. These are the tree trunks for your trees, meant for you to use as guides for how spaced out you would like your trees. Don't worry about making these lines perfect—you will cover most of the black in the next step.

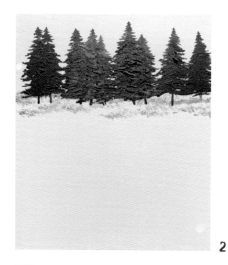

2

STEP 2: Once the black has dried, start working on the first row of trees by forming the branches around the trunks. Each tree will start with thin little branches at the top and fill out and lengthen as you move down the trunk. Imagine a Christmas tree without decorations. Mix up a dark green made from two parts Hooker's Green and one part Mars Black. The top branches are so small that the liner brush will give you the best results. As you go further down the tree, switch to the #2 fan brush. Your brush should be fully saturated with paint. If there isn't enough paint in the brush, you will end up with stray marks and you might have trouble filling in as much space as you want. If you do end up with some stray marks, you can use your liner brush to connect them to the tree, or you can ignore them because this back layer will be mostly covered up by the future layers.

STEP 3: Wait for the previous layer of paint to dry completely. The fan brush lays down a thick layer of paint and it will take longer to dry than you might expect! Wait a minimum of 4 hours, preferably more. I know it's not fun to have to stop, but it will be so much more frustrating if the fog layer spreads the wrong color around your painting.

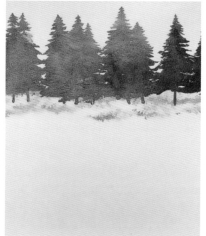

3

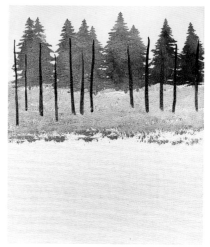

4A

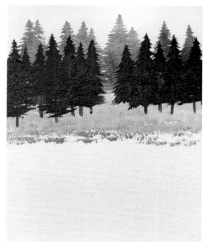

4B

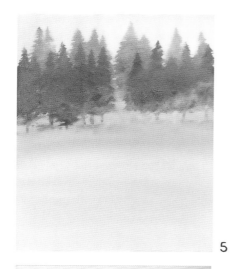

Once the paint is dry, cover the entirety of your painting with a layer of white fog (refer to page 32 if needed). Allow some areas of the fog to be thicker than others—real fog winds through the air and does not cover the landscape in one even sheet.

STEP 4: Load your fan brush with the light gray used in Step 1 and fill in the snow below the trees and down about 2 inches (5 cm). Use your script liner brush to paint in the trunks for the next layer of trees using Mars Black. After you establish your tree spacing, fill your trees with branches the same way you did in Step 2. Use your script liner brush loaded with dark green at the top and switch to your #2 fan brush as you move down the tree for a fuller look.

5

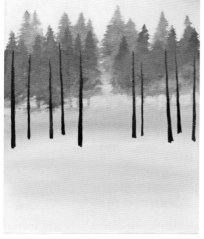

STEP 5: Once these trees are dry, cover the entire painting with a layer of fog, concentrating it a little extra at the bottom of the trees. Covering the first layer of trees at the same time will push the trees further and further back as each layer of fog is added to the painting.

STEP 6: After the fog has dried, add another layer of trees the same way you have in the last few steps. As the trees get closer, though, they should grow taller and a little more spread apart. Stagger the tree trunks a bit at the bottoms to suggest that they grew in a more random pattern than simply in a straight line. Use the same dark green you used for the previous trees to paint on the branches, but allow these trees to be less full and fluffy.

6A

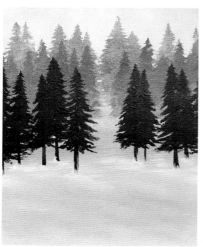

Once your trees are done and the black tree trunks are dry, add a little detail to the snow beneath them. Snow will accumulate at the bottom of the tree trunks and build a little berm of white on one side. I made the snow pile up primarily on the left side of the trunks to imply that wind had pushed the snow toward the right side of the canvas. Use your small round brush and some Titanium White to highlight the fresh snow at the bottom of each tree trunk.

6B

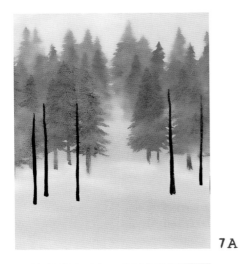

STEP 7: Wait for the previous layer to dry and add yet another layer of white fog. The fog should cover the entire painting and push every row of trees to the back.

Once the fog is dry, lay out your tree placement by painting in some delicate tree trunks. Load your script liner with Mars Black and paint some thin vertical lines where you want your trees. Once this black paint is dry, use your script liner brush at the top and your #8 fan brush toward the bottom. Because this is the final layer of trees, it is the most important time to stagger the tree trunks and to tidy up any stray marks that your fan brush might leave behind.

7A

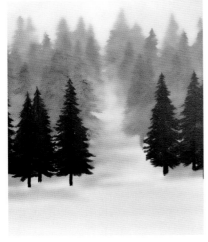

Use your round brush to add some shadows in the snow around the trees with light gray and gentle horizontal strokes. This light gray is made up of Titanium White with just a dot of Mars Black. In the small open space going up the hill, add some of that gray to the left-hand side as cast shadows for the trees on the left of the little clearing. Once the gray is dry, add some Titanium White to the left-hand side of the trunks with your round brush like you did in the last step.

STEP 8: This final row of trees will have the most detail. Each branch will have a highlight painted with a light green. This light green will be two parts Hooker's Green, one part Titanium White and a touch of Mars

7B Black. Use your round brush to follow the motion of each branch with this highlight, even for the branches that are foreshortened on the front of the trees. At the end of each brushstroke, lift your brush to create a narrowed tip at the end of the stroke. These foreshortened branches will appear more vertical than the diagonal ones on the sides.

Before you move onto the next step, take a moment to look at your painting overall and see if you want to alter the fog in the background. In my painting, I dry brushed (refer to page 31 if needed) little wisps of mist over a few of the trees to define some edges and to add variety in the fog.

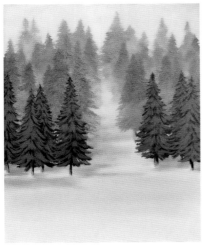

8

9 A

9 B

STEP 9: Apply a fresh layer of white paint over the remaining bit of canvas using Titanium White on your flat brush. While the paint is still wet, add small bits of gray with your flat brush and blend them with horizontal strokes to add dimension to the blanket of snow in the foreground.

Once the new paint is dry, paint a small elk with a little snowy train behind him on the right side of the field. The elk is made up of a dark brown and a medium brown. The bulk of the body is composed of a dark brown made up of Burnt Umber, a small dot of Mars Black and a small dot of Titanium White. Use your script liner brush to paint a rectangular body with four little legs. The two middle legs are going straight down into the snow and the two outer legs are bent and at a diagonal to the body, implying that the elk is walking. The legs are deep in snow, so you won't see the full length of them. Using the same dark brown, create a little neck with a vertical rectangle at the front of the body and create the head with a horizontal trapezoid at the top of the neck.

While the paint is still wet, apply a medium brown to the bottom of the legs, the middle of the body and to the nose. Once the body is done, it's time to add some antlers. Using the dark brown, add two antlers to the elk's head with your script liner. Use a light hand and go slowly. To create the medium brown, mix some Raw Sienna with the dark brown you used for the rest of the elk.

After everything is done and the paint is dry, cover your painting with little snowflakes flitting through the air. Load your fan brush with a watered-down Titanium White and dab off any clumps of paint. Hold the brush perpendicular to the painting and flick the bristles with a clean finger to spray little dots of white onto the canvas.

Once your painting is finished and dry, sign your name with a light gray on the bottom right-hand corner. You worked hard on this painting. Own it!

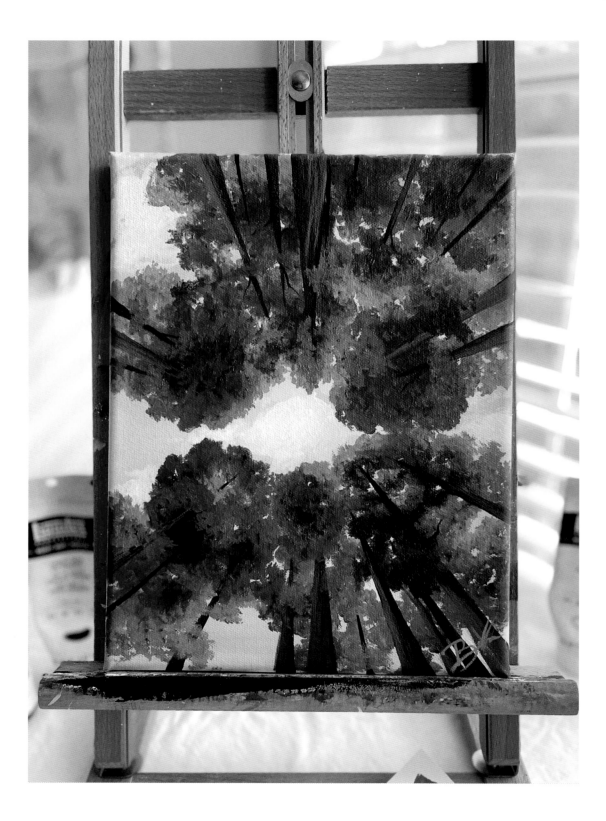

LOOK UP THROUGH THE TREES

When I painted this view for the first time, I was trying to figure out the right scene to encompass the feeling of the winds blowing through the trees. Can you imagine lying on your back and staring up at the sky through the beautiful canopy as the wind sings to you through the rustling leaves? The peace that must envelop you in such a place! This view really pulls in the concept of perspective (see page 27 for a recap if needed). The tree trunks taper toward the sky and are drawn in toward the single viewpoint in the center of the canvas, giving you the feeling that you are IN the painting, feeling the grass on your back and at one with the forest.

MATERIALS LIST

9 x 12" (23 x 31–cm) canvas
Acrylic Paint
- Ultramarine Blue, Red Shade
- Titanium White
- Hooker's Green Hue
- Cadmium Yellow Medium
- Burnt Umber
- Mars Black

Paintbrushes
- 1" (2.5-cm) flat brush
- #4 round brush
- #2 script liner brush

Palette
Towel or microfiber cloth
Clean water

STEP 1: Fill the entire canvas with a light sky blue made of equal parts Ultramarine Blue and Titanium White. Use your flat brush to cover the surface using wide, horizontal strokes that go from one side of the canvas to the other.

2

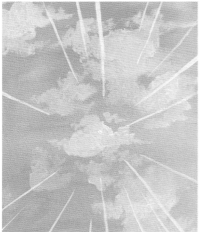

3

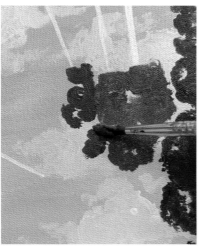

4A

STEP **2**: While the paint is still wet, load your round brush with straight Titanium White paint and loosely paint some fluffy clouds. These clouds won't have flat bottoms because they are being seen from the ground and not as they disappear into the horizon. I like to start my clouds as little blobs while I get the spacing and size the way I want. Then use little wiggling strokes to create irregular offshoots and wisps moving off to the side, to keep them wild like clouds you would see in the sky above us. Keep these clouds toward the center of the canvas and don't get too attached to any particular one. Some of these clouds will be covered up by trees and some will be left out in the open to be enjoyed.

STEP **3**: Make a small white dot in the center of the canvas in a place that you can hide later. Load your brush with Titanium White paint and draw lines going out from the center of the canvas to the outer edges. These lines are intended to be your tree trunks, but I tell you to use white here because it will be easy to hide if, for some reason, one of these lines doesn't work out later on in the painting. This painting is an exercise in one point perspective, and that can take a little practice to get used to.

STEP **4**: Surround these lines with puffs of light green leaves using your round brush and circular brush-strokes. Make these groupings of leaves with a color made of equal parts Hooker's Green and Cadmium Yellow Medium. The leaves are concentrated around the lines, and the thickest part of the trees will be at the top of the lines toward the center of the canvas. In the thickest part of the canopy, darken the leaves with straight Hooker's Green, to indicate less sunlight coming through the leaves.

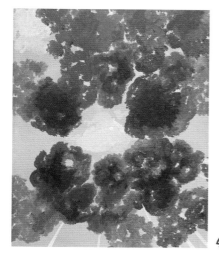

4B

STEP 5: Now let's paint the tree trunks! For the deep brown of the wood, load your script liner brush with a color made up of Burnt Umber, a touch of Titanium White and a dash of Mars Black. Take your script liner and carefully paint in the tree trunks over the lines you had originally painted in white. Each line should taper as it gets closer to the center and widen a bit toward the outside of the canvas. When I painted these tree trunks, I left some with gaps in the trunk to represent areas where leaves cover the wood. This isn't a necessary step as we will be adding leaf coverage later on.

5

STEP 6: Next, add highlights to the spots on the trunks with the least amount of leaves and the highest chance of touching sunlight. For the highlight color, mix a lighter form of the brown you used previously by adding a touch more Titanium White. Keep the highlights streaky to apply a little bit of bark texture down the trunk. Add some small branches throughout the painting with the same dark brown used for the trunks in the previous step and your script liner brush.

Once your trees are dry, finish off the painting by covering up sections of the trunks with leaves. Trees naturally have clumps of leaves spread throughout, so if there are a bunch of tree trunks with no leaves except at the very top, it would look odd. Once you are happy with your painting, make sure to sign it!

6A

6B

MOUNTAIN VIEWS

"The mountains whisper for me to wander; my soul hikes to the call."
-ANGIE WEILAND-CROSBY

Mountains are some of nature's most beautiful creations. We hike through the mountains, up the rocky trails and into beautiful forests, to view the world from a different perspective. The world from the top of a mountain looks so different, and I swear the air up there just fills you with life. Not only is the view from the top magnificent, the slopes themselves are quite a sight to behold. Mountain ranges can differ so widely from one to the next, and each one holds a history so rich and ancient that I can't help but honor them by trying to capture their souls in a painting.

In this chapter, we will focus on painting mountains in different forms and with different perspectives. From silhouettes drenched in mist to entire mountains crowned by the sunset, we get to explore different brushstrokes and painting techniques.

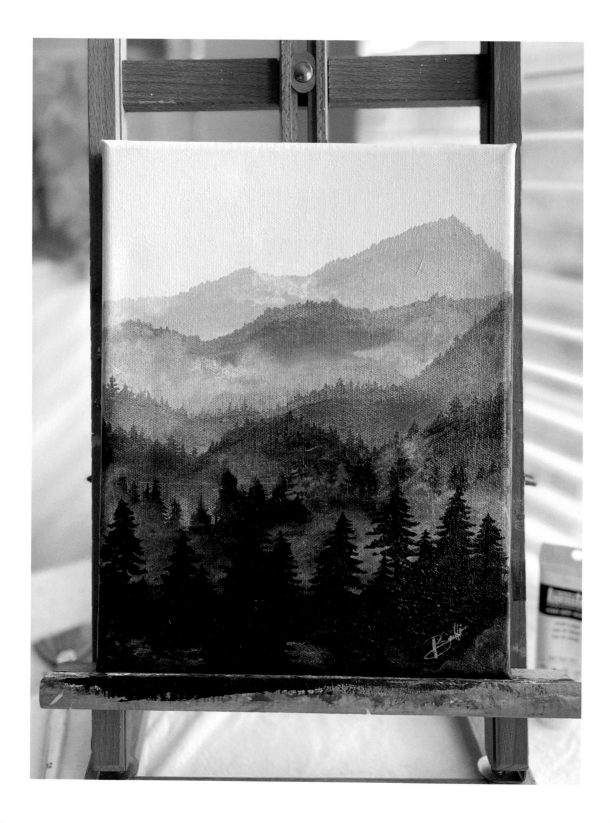

MISTY MOUNTAIN RANGE

This painting is a good example of how you don't need more than two colors to create a world full of intrigue. The only colors used in this painting are Payne's Gray and Titanium White. Each layer gets pushed further and further into the background as you utilize the fog technique (page 32), allowing you to create depth in a unique way.

MATERIALS LIST

9 x 12" (23 x 31–cm) canvas
Acrylic Paint
- *Payne's Gray*
- *Titanium White*

Paintbrushes
- *1" (2.5-cm) flat brush*
- *#4 round brush*
- *#2 script liner brush*
- *#2 boar hair fan brush*

Palette
Towel or microfiber cloth
Clean water

1

STEP 1: For the first step, use your flat brush to create the top of the first silhouetted mountain with a medium gray mixed with equal parts Payne's Gray and Titanium White. The first few layers in this painting won't have much detail, but should have some textured points along the top edge to represent trees. For the trees, use the tip of your round brush to create small pointed brushstrokes along the top edge.

2

STEP 2: Wait for that layer of paint to dry completely before covering it with a thin layer of fog (refer to page 32 if needed). The fog should cover the entirety of the section that you painted in Step 1, concentrating a little extra toward the bottom of the mountain so the bottom half is more obscured.

STEP 3: Use the same medium gray that you used in the first step with some additional Payne's Gray, and create another layer of mountains. These mountains are not following a specific reference photo, so you can add as many or as few dips and peaks as you wish. Fill in a few inches below the top ridge line with the gray using your flat brush. For the texture along the top of the ridge, use the same gray and your round brush to create little points.

STEP 4: Wait for the layer to dry completely, then add another layer of fog covering everything that you have painted so far. Once you're happy with the fog coverage, use a round brush to dry brush some white wisps across several parts of the mountain range (refer to page 31 if needed).

3

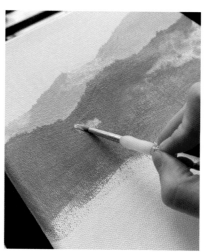

4A

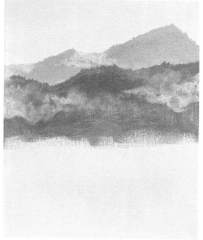

4B

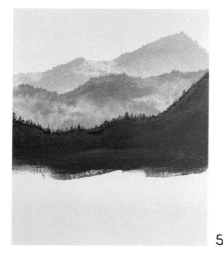

STEP 5: This next layer will have slightly more texture and will be a little bit darker than the previous mountains. The gray mixed for this color will be two parts Payne's Gray and one part Titanium White. Just as before, use your flat brush to fill in a few inches below the top ridge line and your small round brush to create vertical pointed brushstrokes along the top edge. This layer will be slightly different, though, as you will add tiny little branches to a handful of the trees with your script liner brush and the same gray used to create this layer of mountains.

STEP 6: Once again, cover your entire painting with fog once you are sure that it has dried completely.

5

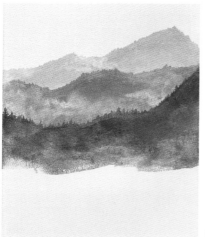

STEP 7: This next layer will use pure Payne's Gray to create the new mountain silhouettes. Line the ridge with detailed trees using your script liner brush. Space the trees out enough that you are able to add small details without feeling overwhelmed.

6

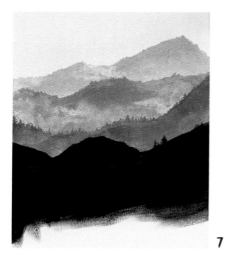

7

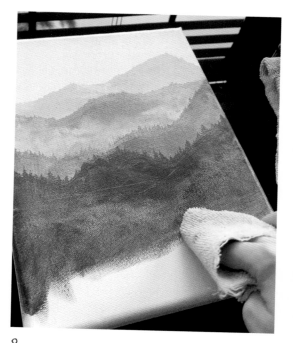

8

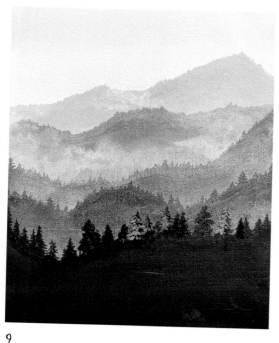

9

STEP 8: Wait for your layer to dry fully, then add another layer of fog. Allow some pieces of this fog to be thicker than others to add interest and dimension to your painting.

STEP 9: Use plain Payne's Gray to cover the bottom of the canvas and to create the final ridgeline. This one will have even more detailed trees than the previous one, as they are larger and closer to the viewer. You can add little highlights to your trees with a mixture of Titanium White and a touch of Payne's Gray, or skip that step altogether.

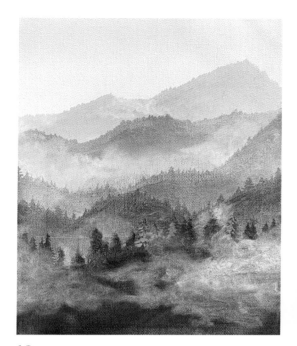

10

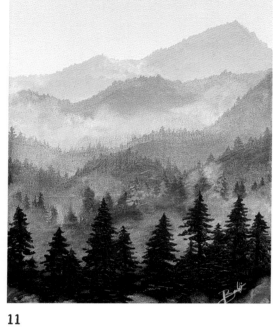

11

STEP 10: Wait for that paint to dry fully before adding fog to the entirety of your painting. Every time you add fog to the entire painting, the mountains get pushed further and further back. This is rather useful because you don't have to focus too hard on what shade each level should be. Before you move on to the next step, create large billows of mist to cover the darkest pieces of the painting. You can use the cloth or a dry brush for this.

STEP 11: Instead of adding another layer of mountains, create a line of trees like the ones in Frosty Pines (page 61). Load your #2 fan brush with plain Payne's Gray and dab in the lower branches before switching to your script liner to finish off the top of each tree with smaller details.

The trees should be spaced out enough that you are able to create little branches with your round brush and allow some of the fog in the previous layer to be seen.

Once your paint has dried, dry brush a little bit of fog along the bottom of the canvas, covering parts of your new trees (refer to page 31 if needed).

After adding in the fog, don't forget to add in your signature.

SNOW-CAPPED SUNRISE

In this piece, we get to explore the textures of a snowy mountain range. Not only are you painting the blankets of snow, but also the rocks peeking through on this lovely mountain, accompanied by a waning moon. This project features wet-on-wet painting as you add touches of color to the sunrise and drifts of snow to the slopes. Gentle colors fill the scene and envelop you with peace as the sun begins its ascent.

MATERIALS LIST

8 x 10" (21 x 26–cm) canvas
Acrylic Paint
- *Ultramarine Blue, Red Shade*
- *Titanium White*
- *Cadmium Yellow Medium*
- *Cadmium Red Medium*
- *Payne's Gray*
- *Mars Black*

Paintbrushes
- *1" (2.5-cm) flat brush*
- *#4 round brush*
- *½" (1.3-cm) flat brush*

Palette
Towel or microfiber cloth
Clean water

1A

STEP 1: For this first step, you will need Ultramarine Blue, Titanium White, Cadmium Yellow Medium and Cadmium Red Medium. Mix together equal parts Ultramarine Blue and Titanium White, and cover the entirety of the top two-thirds of the canvas with your large flat brush. While the paint is still wet, leave the light blue paint on your brush and gently dip your brush into the yellow and red on your palette. Use diagonal strokes across the sky to incorporate the new colors, painting with light and minimal brushstrokes. You want the colors to blend together but not muddy into one solid color.

(continued)

1B

2

While the paint is still wet, use your round brush to trail some Titanium White into the sky to form little wispy clouds.

STEP 2: When the paint has dried, create a silhouette of a mountain range, using a flat brush and a dark blue-gray color made up of one part Ultramarine Blue, one part Payne's Gray and a touch of Titanium White. Use this color to cover the rest of the unpainted canvas. Don't worry about making the coverage perfectly even—we will be layering shadows and highlights over most of this in the next few steps.

STEP 3: Use a darker blue-gray made up of one part Ultramarine Blue and one part Payne's Gray to create some shadows and to bring some structure to these mountains. You can use your round brush for this, but I enjoy using the ½-inch (1.3-cm) flat brush to carve out the shapes. The shadows should fall on the left-hand side of each peak across the scene. The shadows don't need to be perfect as you play with the placement of each hill, as they will likely change throughout the painting process. Add two large hills to the bottom of the canvas with your flat brush to create the foreground.

Before moving to the next step, use some Mars Black and your round brush to deepen the shadows along each ridge, defining the edges of each slope.

3A

3B

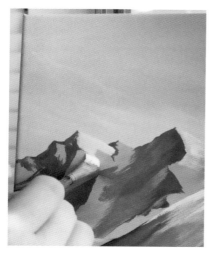

4A

4B

5

STEP 4: Now it's time to add the highlights. Start with a lighter gray by adding Titanium White to any of the grays that you have on your palette from the previous steps. Use your ½-inch (1.3-cm) flat brush to slide the paint across the canvas and over the right-hand side of the peaks. For the most part, use the gray as your highlight. Titanium White should only be used at the highest points of the peaks or any of the edges that you want to define.

STEP 5: For the finishing touches, use tiny bits of plain Payne's Gray to add little pieces of rock showing through the snow in the mountains on the left-hand side in the shadows. These do not need to be in any specific spot and should be painted with short and choppy brushstrokes using your ½-inch (1.3 cm)) flat brush or #4 round brush.

To add the moon, load your round brush with Titanium White and carefully paint half a circle just above the mountains. When you fill it in, leave a little bit of the sky showing through to represent the shadows of the craters of the moon.

Don't forget to autograph that masterpiece once it's complete!

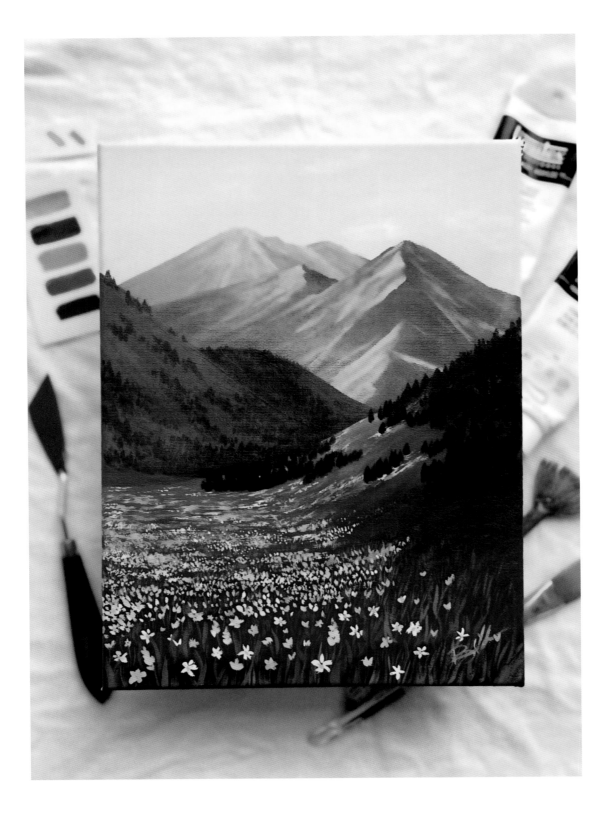

SPRING IN THE MOUNTAINS

The beginning of spring is such a special time of year as the flowers begin to bloom and joy spreads across the landscape. This painting explores a few different ways of creating depth as you push the mountains into the background with fog and play with the perspective of the wildflower field.

MATERIALS LIST

9 x 12" (23 x 31–cm) canvas
Acrylic Paint
- Titanium White
- Ultramarine Blue, Red Shade
- Mars Black
- Hooker's Green Hue
- Cadmium Yellow Medium
- Cadmium Red Medium

Paintbrushes
- 1" (2.5-cm) flat brush
- #4 round brush
- #2 boar hair fan brush
- #2 script liner brush

Palette
Towel or microfiber cloth
Clean water

1

STEP 1: Use your flat brush to fill the top half of the canvas with a very light blue made of Titanium White and a tiny bit of Ultramarine Blue. After your sky has dried, load your flat brush with a medium gray made from two parts Titanium White and one part Mars Black to block out the first mountains. Allow for some color variation during this step—it helps add dimension to the mountains! While the paint is still wet, use a round brush to blend some Titanium White into the peaks with strokes that radiate from the topmost point. Let this layer of paint dry.

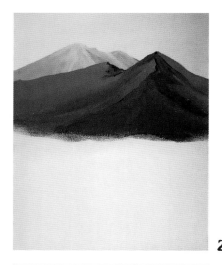

STEP 2: This next set of mountains will be painted with a blue-tinted dark gray. For this gray, mix two parts Mars Black with one part Titanium White and Ultramarine Blue. Offset the peaks to the right side of the painting so you can still see the mountains in the background. I like to use the flat brush to block in the large shapes quickly. While the paint is still wet, use your round brush loaded with Mars Black to add shadows to the slopes on the right side of each peak. Let the black blend into the main mountain color a bit so the colors aren't too starkly contrasting.

2

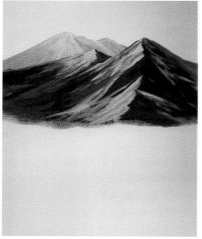

STEP 3: Now let's add some depth! Mountains are powerful landmarks, full of grooves and peaks that catch the light and add contrast to the scenery. Mix a light gray for the highlights, starting with the medium gray from Step 1 and adding enough white to make it stand out from the base of the mountain. Use the light gray and your round brush to add highlights to the left side of each slope and small accents on the right sides.

As you add the highlights and lighten the mountains, you might find places in your mountains that need some more shadow. Use your round brush to add Mars Black to the slopes on the right-hand side of the mountains and down in the low spots on the left of the canvas.

3

STEP 4: Allow your painting to dry through completely, for several hours or more, before adding a layer of fog with a cloth and Titanium White paint (refer to page 32 if needed) over everything you have painted so far, pushing it all back into the distance.

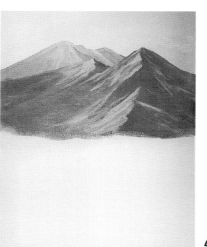

4

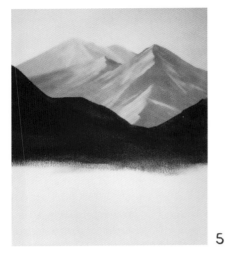

5

STEP 5: Block in some hills in the midground with Hooker's Green and your flat brush. Use these hills to frame the mountains in the back, making sure not to cover up your hard work!

STEP 6: Fill each hill with different shades of green, from the darkest one in the back to the lightest in the front. The hill in the center is the farthest back and has the most blue paint mixed with the green. This green is mixed with equal parts Hooker's Green and Ultramarine Blue with a touch of white to bring the colors out. The second hill is mixed with two parts Hooker's Green, one part Ultramarine Blue and a bit of Cadmium Yellow Medium. The last one is painted with this same color but gets lighter at the base of the hill with additional yellow mixed in.

Once the paint is dry, use your round brush to make small trees covering the hills, each one made with a dark green of equal parts Hooker's Green and Mars Black. Use the tip of the brush to make pointed tops and round bottoms for the trees.

STEP 7: Allow your painting to dry before adding white fog to the two hills on the left side of the canvas. Try to avoid the hill on the right side.

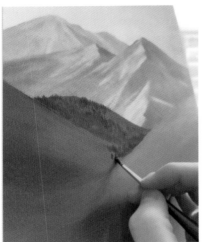

6 A

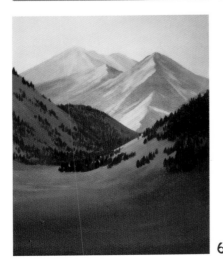

6B

7

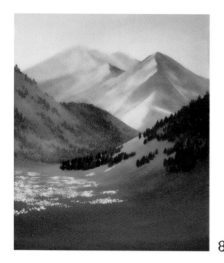

8

STEP 8: Start adding small patches of wildflowers in the field. I used my fan brush along with my script liner to add the tiny details. The flowers are made with pink, yellow and white. For the pink, mix a small dot of Cadmium Red Medium with Titanium White paint. For the yellow, add a touch of Cadmium Yellow Medium to Titanium White paint, and use plain Titanium White for the white flowers.

For the flowers in the back, gently dab your brush (refer to page 32 if needed) across the field to create horizontal stamps with your fan brush, intermingling the different colors of flowers. For furthest flowers, use a bit more of a swiping brushstroke rather than a dab, but only for a few patches in the way back. Let most of the flowers be dabbed on with the fan brush. Where the field meets the first hill on the right, turn your fan brush slightly upward so the flowers follow the direction of the ground in that area.

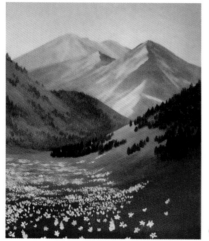

9

STEP 9: Start bringing the flowers into the foreground. The flower patches get larger and the flowers sprout petals and leaves as they get closer to the bottom edge of the canvas. The field has a variety of flower types: some flowers are white with yellow centers while some are yellow and resemble hearts. Some pink ones are sprinkled throughout, with rows of petals stacked upon each other. Your script liner brush is very helpful for details like this. Use the same colors that you used in Step 8 to form the flowers in the foreground.

STEP 10: Continue adding more detailed flowers at the bottom of the canvas and use a light green to paint some stems, leaves and grass throughout the field with your script liner brush. Sign your name in the bottom corner of the painting with a contrasting color. I chose to sign my painting with a light yellow-green so it stands out against the dark green grass but matches the stems around it.

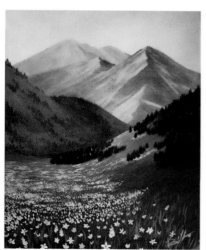

10

ROAD TRIP THROUGH THE MOUNTAINS

I spent long hours in the car traveling from the Southern US to the mountainous Western US and have marveled at the incredible roads winding through rows of pine trees that frame the mountains in the distance. This piece uses many techniques that pull you into the journey. From fog winding through the pine trees to the perspective of the road, this project will pull together multiple kinds of skills and will show you how absolutely capable you are.

MATERIALS LIST

9 x 12" (23 x 31–cm) canvas
Pencil
Acrylic Paint
- Titanium White
- Ultramarine Blue, Red Shade
- Mars Black
- Hooker's Green Hue
- Cadmium Yellow Medium

Paintbrushes
- 1" (2.5-cm) flat brush
- #4 round brush
- #2 script liner brush
- ½" (1.3-cm) flat brush
- ⅛" (3-mm) dagger brush
- #2 boar hair fan brush

Palette
Towel or microfiber cloth
Clean water

1

STEP 1: I started this painting with a sketch. This is not required, but it's helpful in planning ahead. With a pencil, lightly sketch the road, a tree line and the mountains in the back. You shouldn't spend too much time on the sketch because it will get painted over.

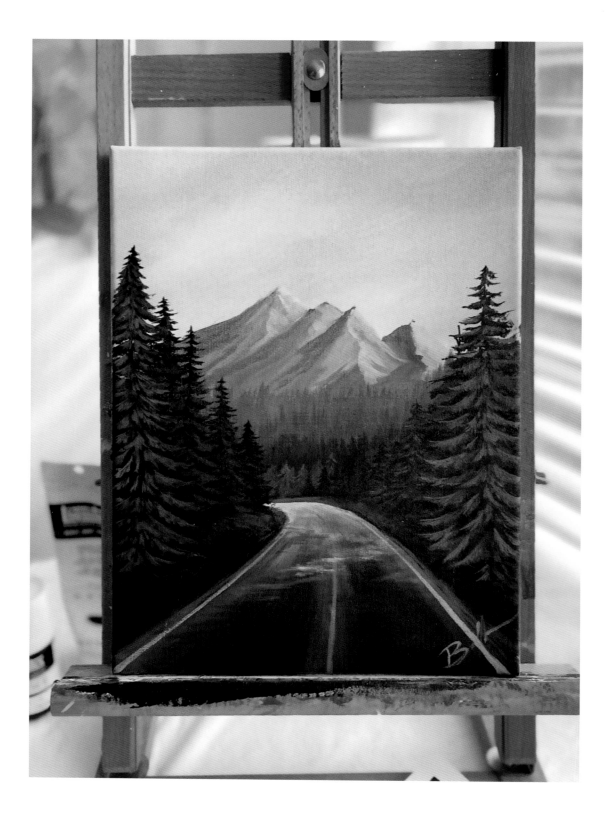

STEP 2: Mix a light sky blue with two parts Titanium White and one part Ultramarine Blue. Use your flat brush to cover the top third of the canvas. While the paint is still wet, dip your brush in some pure Titanium White and create some wispy clouds with gentle brush-strokes across the sky.

STEP 3: Once the sky is dry, load your flat brush with a medium gray made up of two parts Titanium White and one part Mars Black, and block out the mountain placement. The peaks land in the center of the canvas, following the placement you drew in the first step.

2

STEP 4: Once you like where your mountains are, begin adding dimension to the mountains. Use your round brush to apply some dark gray down the slopes on the left-hand side of the mountain to define the ridge lines that run down the front of each mountain. Use the same gray you mixed in Step 3, but add more black; this shade of gray should not be fully black but should be darker than the base mountain color. The placement of your mountains may change as you shade them and that's all right. Allow yourself to go with the flow.

3

4

5

6

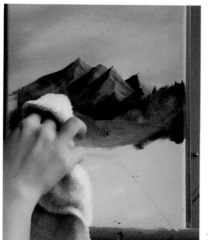

7

STEP 5: After your shadows dry completely, add highlights to the right side of the mountains with a light gray made up of Titanium White with just a touch of Mars Black. Keep your brushstrokes light and allow the texture of the canvas to show through. With a clean round brush, add a touch more Titanium White to your brightest highlights just along the ridgelines to add the final detail to your mountains.

STEP 6: Add a tree line across the entirety of the canvas, just under the mountains. Begin by blocking out the bulk of the shape with dark green and your flat brush. This dark green is made up of two parts Hooker's Green and one part Mars Black. When you are happy with your overall shape, use your round brush and the same dark green to create the treetops with vertical strokes, lifting your brush at the end to create a point each time. If you would like to, you can leave some of the hill less textured, as you can see on the right-hand side of the painting where I left a bit of earth with no tree coverage.

STEP 7: Wait for that layer of paint to dry completely before adding a layer of fog over the entirety of the mountains and the trees (refer to page 32 if needed). This layer of fog evenly covers the entirety of the painting, including the mountains, to push everything into the distance.

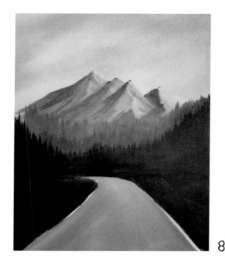

8

STEP 8: After the fog layer dries, add another tree line with a hill high on the right side trailing down in the center and rising again on the left side of the canvas. Use the same dark green that you used in Step 6. This will help frame the mountains in the background. Use your flat brush to fill in the areas on either side of the road with the same dark green.

Mix a light gray with equal parts Titanium White and Mars Black for the road. Use your flat brush to fill in the entirety of the road that you mapped out in Step 1.

STEP 9: For this next step, you will need a light green. This is mixed with equal parts Hooker's Green and Titanium White. Use your round brush to paint small, lightly detailed trees at the top of the road. This is a focal point for the end result, but the trees don't need to be very defined because they are relatively far away. Use this light green to highlight the top layer of grass across the ground on either side of the road, defining the foreground from the trees in the back.

STEP 10: Wait for your painting to dry completely. Once you are positive that it is dry, add a light layer of fog. Keep the fog localized to just along the horizon line made where the road curves into the distance. Avoid covering the road itself with the fog to give the appearance that the fog is rolling over the gentle hills alongside the road.

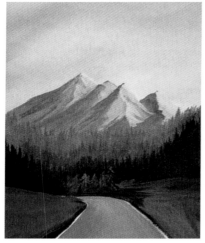

9

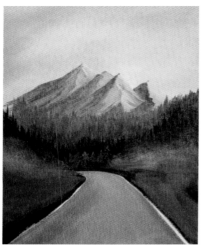

10

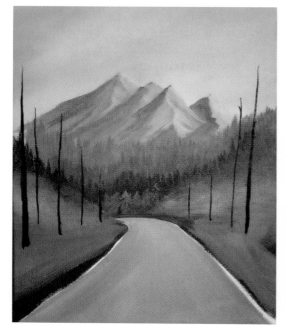

11

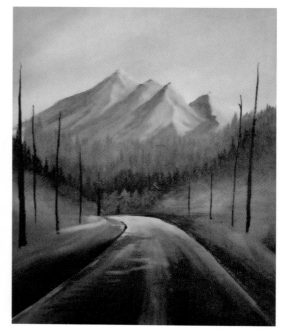

12

STEP 11: Use Mars Black for this next step. I used a soft body black, but if you don't have one, that is okay! Just add a little water to thin out your paint. Load your script liner brush with this thinned-down black to paint delicate lines that will become the trunks of your trees in the next step. The lines should be taller toward the edges of the canvas and shorter toward the top of the road to create depth and draw the viewer's eye to the farthest bend in the road at the horizon line.

STEP 12: It's time to add details to the road. Have multiple shades of gray available on your palette while you work: a light gray, a medium gray and a dark gray made up of Titanium White and Mars Black. Using the darkest gray, create two gradients in the center of the road to suggest tire marks. Have the top of the gradient fade off about two-thirds of the way up the road and allow the texture of the canvas to show. Next, add some horizontal lines with your medium gray and your light gray to add texture and dimension to the road. For details like this, I like to use the ½-inch (1.3-cm) flat brush and move it horizontally to make lines. This can give you more control over the outcome than if you were to use a round brush or liner brush.

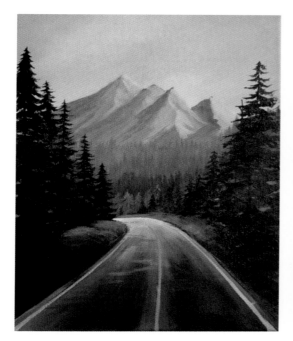

13

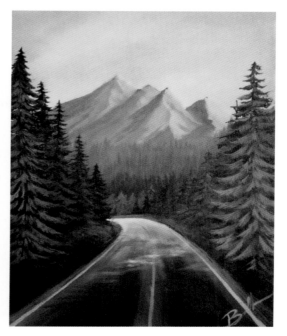

14

STEP 13: Load your dagger brush with Mars Black and a bit of Hooker's Green and start carving out your trees. Start your brushstrokes at the tree trunk and swoop down with your stroke, lifting up at the end for a pointed tip on each branch. Each branch gets wider toward the bottom of the tree and gets smaller toward the top. You can switch to your #2 fan brush as you approach the larger branches if you need to. Allow some spaces between the brushstrokes so you can see the colors of the layer underneath. Remember to make the trees at the curve of the road the smallest and the ones at the edge of the canvas the largest.

Use the same Mars Black with a touch of Hooker's Green to darken up the ground framing the road.

Now for the road. To create the lines on the side of the road, load your script liner brush with a light gray. For this light gray, mix Titanium White with the smallest touch of Mars Black. These lines should not be stark white but should be much lighter than the rest of the road. Taper the line as it gets further down the road, allowing the line at the bottom of the canvas to be the widest part. For the yellow center line, use the same light gray mixture but add a dab of Cadmium Yellow Medium.

STEP 14: The last step is to add details to the trees. Mix a light green with Hooker's Green and a dab of Titanium White for this highlight layer. Use your script liner brush to carefully place the pine needles on the branches. The trees at the edges of the canvas should be the lightest and any highlights added to trees further back should be darker (add additional Hooker's Green to your mix).

Remember to sign your masterpiece with a contrasting color in the bottom right-hand corner of the canvas!

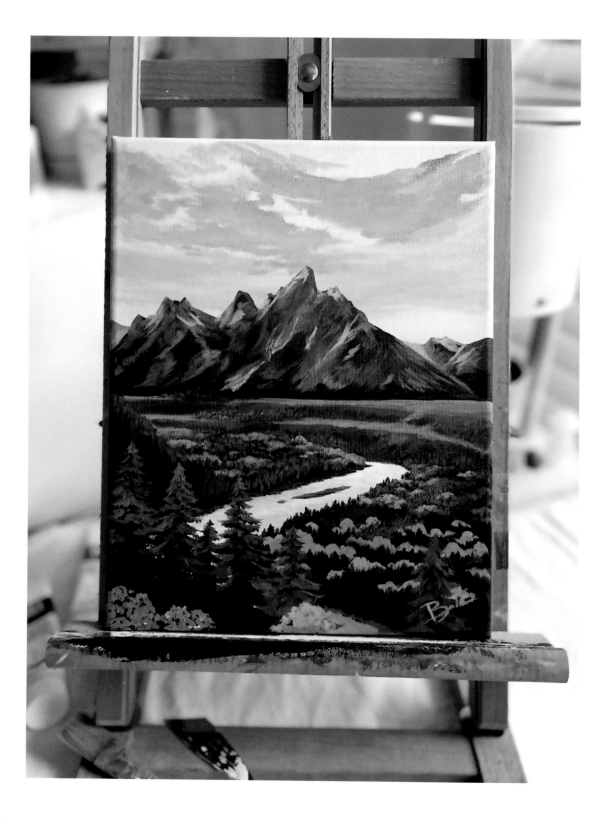

SUN SETTING IN THE TETONS

The Teton mountains are breathtaking and truly encompass the power that mountains personify. They stand tall and strong, their spirit filling the space with their presence. This piece brings color and life to the landscape and pulls the viewer out to stand on another peak to take in the valley as well.

This is the most complicated painting in this chapter, as we play with tonal contrast and atmospheric perspective without the help of the fog technique. There are many details and colors throughout this painting that really bring out your brushstrokes and the skills you have learned as you have practiced using your brushes in the previous paintings.

MATERIALS LIST

9 x 12" (23 x 31–cm) canvas
Acrylic Paint
- Ultramarine Blue, Red Shade
- Titanium White
- Cadmium Red Medium
- Cadmium Orange Medium
- Dioxazine Purple
- Mars Black
- Hooker's Green Hue
- Cadmium Yellow Medium

Paintbrushes
- 1" (2.5-cm) flat brush
- #4 round brush
- ⅛" (3-mm) dagger brush
- ½" (1.3-cm) flat brush
- #2 script liner brush
- #2 boar hair fan brush

Palette
Towel or microfiber cloth
Clean water

1

STEP 1: Begin by mixing a sky blue by adding a small touch of Ultramarine Blue to Titanium White. Load your large flat brush and spread your color evenly across the top half of the canvas.

2

3

STEP 2: Once the blue sky is dry, we get to create the brilliant clouds that are colored by the sun setting behind the mountains. For this we will be using Cadmium Red Medium, Cadmium Orange Medium and Dioxazine Purple. As you begin this process, keep an eye on your paints and your paintbrush. The goal is to add color to the sky without it being too streaky and without it being too blended. I find that the best way to do this is to load your brush with multiple colors without mixing them and spread them on the canvas, allowing them to blend only a little.

To begin establishing where the clouds are going to go, start with a light pink and a light orange. For the light pink, mix a small amount of Cadmium Red Medium with Titanium White. To create your orange, use the same technique, adding a small amount of Cadmium Orange Medium to fresh Titanium White.

Begin creating horizontal brushstrokes toward the bottom of the sky with both your light pink and your light orange. Just as we have covered in the concept of perspective, the clouds at the bottom of the sky will be thinner and less detailed, and the clouds toward the top of the canvas will have more detail and a richer color.

Use the Dioxazine Purple as the shadow color. Shade the tops of the clouds instead of the bottoms because the tops of the clouds are hidden from the sun as it goes down past the horizon. Use quick and meaningful brushstrokes to blend your oranges, pinks and purples while they are wet to allow the colors to blend without too much effort.

STEP 3: Mix a dark purple color with Dioxazine Purple, Mars Black and the smallest touch of Titanium White. Use this color and your flat brush and small round brush to outline the silhouette of the Teton mountain range; use the flat brush to create sharp peaks and the round brush to help smooth the edges of the dips in the mountain. Follow the general outline that I have on my painting. This does not have to be perfect, but the middle peak is iconic and will help others see the vision if it is included in the painting. Fill in the silhouette to the halfway point of the canvas.

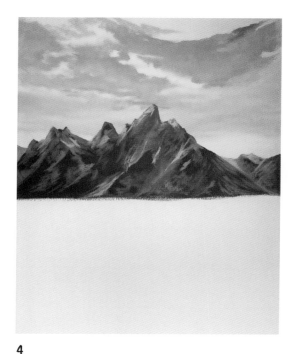

4

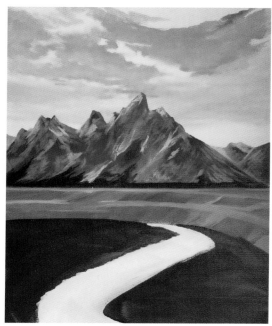

5

STEP 4: To shade the mountains, we will be using the same dark purple we used in the last step, but with bits of white added to create two different shades. You want to mix a medium shade and a light shade to have available as you add texture to the mountains. The highlights on the mountains are not pure white but a rather light shade of the same dark purple. When mixing your different shades, keep using the same dark purple with the mix of black because we want it to stay desaturated. Without the black, it will be quite vibrant and will stand out in a negative way. I used a small dagger brush to help me control where I put my brushstrokes. The highlights need to be constrained to the highest points, and your medium shade shouldn't completely cover the base color as you add ridges and texture.

STEP 5: Establish the shapes that will make up the rest of the painting. These include a river, some hills and some dense forest. Mix up a light green, a medium green and a dark green. The light green will be a mixture of equal parts Hooker's Green and Titanium White with a dot of Mars Black, while the medium green will be two parts Hooker's Green, one part Titanium White and a touch of Mars Black. The dark green can be straight Hooker's Green, as it is mainly just used to fill in the shape of the forest floor for later use. Go ahead and fill in the river with a sky-blue color from Step 1 and saturate the surrounding areas with Hooker's Green.

Create two steps in the hillside by using your flat brush loaded with light green to paint horizontal lines that arc gently downward on the right side of the canvas. The shadows will be the medium green dragged down diagonally from the right to the left with your flat brush to imply a slope rather than a steep drop.

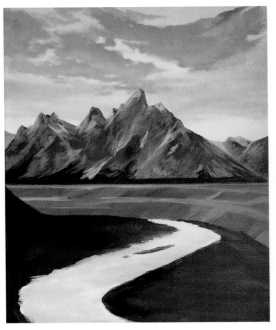

6

7

STEP 6: I further established the valley by adding another hill on the left-hand side of the canvas toward the bottom. Next, we're going to use horizontal strokes on the river to incorporate the colors of the sky. These don't have to perfectly mirror the sky, but we want to keep the colors similar because they are a reflection of the beautiful sunset. I used the ½-inch (1.3-cm) flat brush to make the horizontal strokes in the river using the light pink and light orange from Step 2.

STEP 7: Once the paint has dried, start adding the little trees to the forest. There's a mixture of evergreens and color-changing deciduous trees that have different textures and shapes. The color-changing foliage will be rounder and fluffier while the evergreens are pointy and thin. Use your small round brush to create both of these shapes, moving to the script liner for the pine trees if needed.

The colorful deciduous trees are a light green and light orange. For the light green, mix equal parts Cadmium Yellow Medium and Hooker's Green. Add just a touch of Titanium White to desaturate the color. Use small circular motions for these trees and add little dabs of light orange just around the tops of the little fluffs. I used my round brush to dry brush some Cadmium Yellow Medium (refer to page 31 if needed) onto the hills just along the crests to highlight the warm light cast onto them from the sunset. The pine trees will be made with Hooker's Green and small touches of both Titanium White and Mars Black. Small pointed strokes are the best for small pine trees. Don't worry about adding smaller details like branches, as these trees are too far away to see them.

8

9

STEP 8: Once you're comfortable with adding trees, continue down on the right side of the river, making the trees slightly larger as they get closer to you. They don't need to be much larger, just large enough to show that they are slightly closer to the viewer. Fill the hill on the left side with pine trees using small pointed brushstrokes and the green mixture from Step 7.

STEP 9: The trees in this step are going to be much larger to imply that we are standing on a separate hill looking out over the valley. The trees that are on the hill with us are impeding a small amount of our view. Fill in your pine trees with as much or as little detail as you would like, using Mars Black as the base color and adding Hooker's Green as a highlight.

Paint these trees much like the ones in Frosty Pines (page 61) or the final row of trees in Misty Mountain Range (page 73). Start with your script liner to establish the tree trunk placement, and use a small round brush to carve out the top branches and your #2 fan brush to paint the larger branches.

Once the pine trees are completely dry, add some orange leaves peeking up from off the bottom of the canvas as a continuation of the other color-changing deciduous trees and a nod to the orange in the sky.

As you finish your painting, sign your name and take a moment to admire the beautiful scenery you painted.

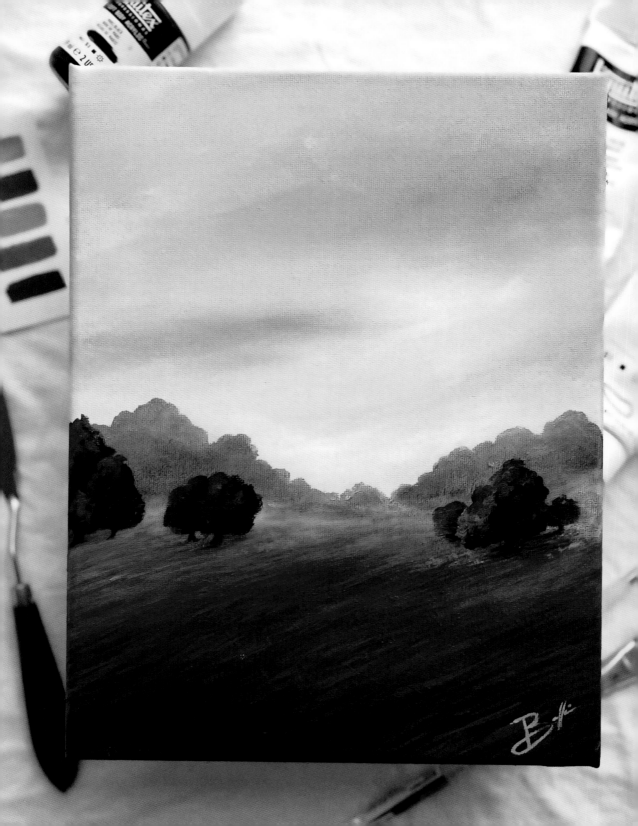

OPEN SKIES

"The air up there in the clouds is very pure and fine, bracing and delicious. And why shouldn't it be?—It is the same the angels breathe."

-MARK TWAIN

The sky is so vast and filled with endless wonder. Its ever-changing nature lends it to so many incredible scenes with deep moody clouds and bright vibrant sunsets filled with life. The skies are fluid in nature, moving at all times and shifting from day to night as the sun rises and sets.

In this chapter, we explore depth, mood and a myriad of techniques to build these worlds of our own making. We will use both wet-on-wet and wet-on-dry painting to build up the foundations of the skies in these projects, each one composing a different song. Vibrant sunsets and storm filled-skies lie ahead.

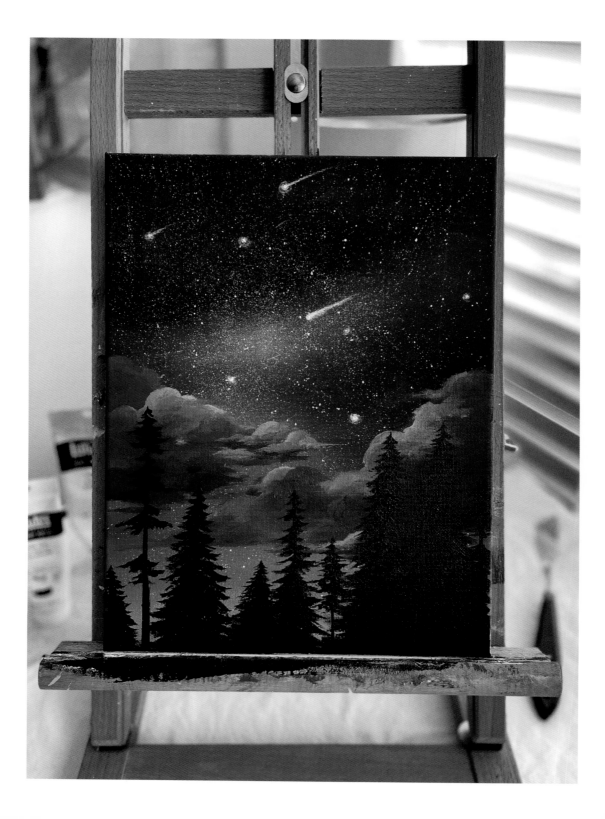

CELESTIAL SKY

As a child, I used to sit outside at night with my grandfather and look for shooting stars. It was always a little chilly, so we would cuddle up in soft blankets and see who could find the most stars. This piece is a mystical sky filled with deep, rich colors and shooting stars inspired by those late-night memories. This painting plays with wet-on-wet blending as we use light and airy brushstrokes for the sky and striking, precise strokes for the silhouettes.

MATERIALS LIST

9 x 12" (23 x 31–cm) canvas

Acrylic Paint

- Ultramarine Blue, Red Shade
- Cadmium Red Medium
- Titanium White
- Dioxazine Purple
- Mars Black

Paintbrushes

- 1" (2.5-cm) flat brush
- #2 boar hair fan brush
- #4 round brush
- ½" (1.3-cm) filbert brush
- #2 script liner brush

Palette

Towel or microfiber cloth

Clean water

1

STEP 1: This sky is filled with a range of deep blues. A dark blue made of equal parts Ultramarine Blue and Cadmium Red Medium covers the top third of the canvas, fading into Ultramarine Blue and finally into a light blue of Ultramarine Blue and Titanium White. Use the flat brush to fill the canvas with horizontal strokes spanning from one side of the canvas to the other, transitioning from dark to to light. Once you have a nice gradient and the paint is still wet, add some Titanium White to some small sections, using crisscrossing motions with your flat brush to blend the colors together.

STEP 2: Stars can be kind of tricky to paint. No one wants to sit and place each individual star on the canvas. To speed up the process, use your small fan brush to flick white paint onto the deep night sky you have created. The best method for this, I've found, is to load your fan brush with Titanium White that has been thinned down with water. Wipe most of the paint off so no large globs of paint are on the bristles. Hold your brush so the bristles are perpendicular to the canvas and use your other hand to pull the paint-filled bristles back, releasing them quickly so paint flies off the brush and onto the canvas. Hopefully only small dots will appear. If you have some splatters or lines, wipe them off quickly with a clean wet brush and they should be easily removed.

STEP 3: Add some shooting stars and add a little halo of light around some of the bigger flecks. For the shooting stars, place a small dot of Titanium White paint on a star and swipe a clean finger over it in the direction you want the star's tail to go. For the radiating light, dry brush little circles around some stars with your clean, dry round brush and Titanium White.

STEP 4: When everything is dry, add some dark clouds about a third of the way up the canvas. With a color made up of equal parts Ultramarine Blue and Cadmium Red Medium, load your filbert brush and use circles to build up the clouds into the shapes that you want. Every now and then, drag some paint off horizontally to make little wispy pieces. The bottoms of the clouds should be flatter than the tops, so make sure to keep the tops fluffy and rounded and the bottoms flatter and wispy.

5A

STEP 5: This step works best if the clouds are still wet because it aids in blending, but it's not a deal-breaker. Mix up a color to highlight the clouds with Ultramarine Blue, a touch of Titanium White and a dot of Dioxazine Purple. Use the same filbert brush to spread this color across the top curves of the clouds. Blend the color down into the clouds a bit, bringing the shapes to life with each stroke. If you are having a hard time blending the colors, add some fresh dark blue so each color is wet and malleable.

STEP 6: Load up your script liner brush with Mars Black to draw out the tree trunks for the next step. Stagger the heights and leave enough space between the trees to allow some of the lighter sky to show through.

STEP 7: Fill the trees with pine-needle-filled branches. Use a small brush loaded with Mars Black for the details at the tops of the trees and the #2 fan brush for the branches lower down, again with Mars Black. Some of the trees will be fuller, with less space between the branches, and some will be more spaced out and sparse.

5B

6

7

LINGERING LIGHT

Those last few minutes of sunlight at the end of the day are so very special. The sky lights up with pinks, yellows, oranges and purples and fills the world with color. I love to watch the sky evolve as the sun falls beneath the horizon and the world grows quiet.

In this project, we will be playing with those vibrant colors, movement and wet-on-wet painting.

MATERIALS LIST

9 x 12" (23 x 31–cm) canvas
Acrylic Paint
- Titanium White
- Ultramarine Blue, Red Shade
- Cadmium Red Medium
- Cadmium Yellow Medium
- Cadmium Orange Medium
- Hooker's Green Hue

Paintbrushes
- 1" (2.5-cm) flat brush
- #4 round brush

Palette
Towel or microfiber cloth
Clean water

1

STEP 1: With your flat brush, map out the placement of your clouds by painting the sky with Titanium White where you plan to have clouds and blue where you plan to have an open sky. For the blue, use a mixture of two parts Titanium White and one part Ultramarine Blue. This step doesn't have to be perfect and can change later.

STEP 2: Once the blue sky is dry, fill the white parts of your sky with color. Mix up a few vibrant colors: pink, yellow and orange. These three colors will be added to the clouds and blended together for the most part. For the pink, use two parts Titanium White and one part Cadmium Red Medium. For the yellow, use equal parts Titanium White and Cadmium Yellow Medium. For the orange, use equal parts Titanium White and Cadmium Orange Medium.

(continued)

To apply the colors, use your flat brush and swipe it horizontally to make curved lines rather than large swipes of paint. This painting evolves through the process, so don't feel like every brushstroke has to be placed perfectly; just follow the basic shapes and movement of the clouds. As you paint, keep the yellow mainly along the left sides of the clouds because that's where the sun is highlighting them.

STEP 3: Use the original sky color to add some more blue to the area right above the horizon line and to clean up any parts of the clouds that might need it. In this step, start adding some muted purples. For the purple, mix Ultramarine Blue, Cadmium Red Medium and Titanium White. Apply the color with your round brush to the underside and right-hand side of the clouds on the bottom.

STEP 4: Fill the empty portion of the ground with green and sign your name! This green is made up of two parts Hooker's Green, one part Titanium White and the smallest touch of Cadmium Red Medium. While the green is still wet, swipe in some pinks and yellows to the upper left-hand side of the grass for some color variation and to tie in the colors of the sky.

2A

2B

3

4

BEFORE THE STORM

In this piece, I will walk you through painting a stormy sky over a silky field of grass. Clouds can be overwhelming to paint, and storm clouds even more so. They have a personality that is entirely their own, and we can only hope to rein it in enough to portray it on canvas. Don't let me stress you out, though. Throughout the process of this painting, I will walk you through mapping out your shapes, defining the edges of each billowing cloud and building up the long blades of grass blowing in the wind.

MATERIALS LIST

8 x 10" (21 x 26–cm) canvas
Acrylic Paint
- Titanium White
- Ultramarine Blue, Red Shade
- Mars Black
- Hooker's Green Hue
- Payne's Gray
Paintbrushes
- 1" (2.5-cm) flat brush
- #8 round brush
- #4 round brush
- #2 script liner brush
Palette
Towel or microfiber cloth
Clean water

1

STEP 1: Cover the top half of the canvas with Titanium White paint using a damp flat brush. Soft body paint will be helpful in this step because it covers the area well, but you can use what you have, adding water if the paint gets difficult to spread. While the white paint is still wet, load your brush with white paint and a dot of Ultramarine Blue. You don't have to mix these colors on your palette—we will mix them on the canvas. Use horizontal strokes and create a gradient of blue to white, with the lightest part on the bottom of this section.

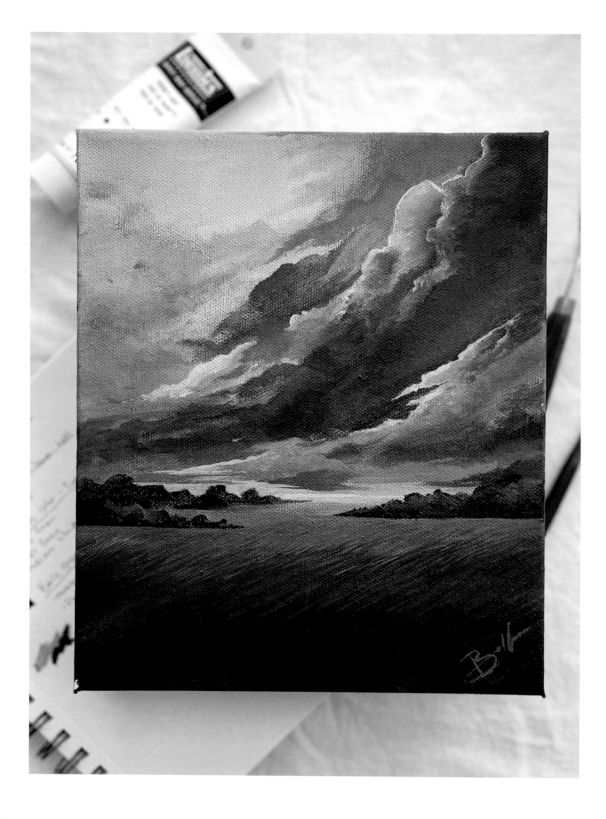

2

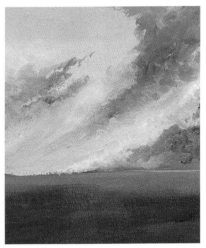

3

4

STEP 2: While you wait for the first layer of your sky to dry, load your flat brush with a darkened Hooker's Green. To make this green, mix equal parts Mars Black and Hooker's Green. Cover the bottom half of the canvas with this color and add a touch of white along the top of this section to create another gradient. The lightest shade in this section should be at the horizon line. Don't worry if your coverage isn't perfectly smooth; you will be adding another layer to the grass.

STEP 3: This is when we start shaping our rainstorm. Mix a dark gray and a light gray for this step. The dark gray will be equal parts Titanium White and Payne's Gray while the light gray will be two parts Titanium White to one part Payne's Gray. Load your #8 round brush with the dark gray and fill in a few sections that will be the darkest parts of the storm. I like to use circular motions to mimic the movement of clouds. When you're happy with the placement, completely wash your brush and use your light gray to gently blend out the dark gray with small circular motions. Be careful not to blend so much that you lose your shapes!

STEP 4: Once your paint has dried, use your round brush to define a few of the clouds. For the darkest spots, use the dark gray that you mixed up in the last step. You are deciding the overall movement of the piece in this step. I chose to have my clouds sweep up from the left and create an arc across the sky to the upper right-hand corner. Keep this step somewhat minimal, as these dark lines will draw your viewer's eye, and we don't want too many focal points to fight for their attention. You will also add the tree line during this step to define the horizon line. Recreate your dark green mixture of Hooker's Green and Mars Black, and load your #4 round brush. Keep the bottom of the tree line pretty flat and the top rather bumpy. These trees will not have any more detail than a silhouette.

5

6

STEP 5: Time for some fog! For this step, your painting will have to be 100 percent dry. You may need to wait anywhere from several hours to a full day before this next step so you don't accidentally smear unwanted paint across your painting. When you are sure your painting is dry, apply a thin layer of fog (refer to page 32 if needed) to the trees and bottommost layer of the clouds; it is okay if the fog extends into other areas.

STEP 6: Once the fog is dry, let's begin defining our shapes and adding more trees. Take a moment to appreciate the painting as you have it. Follow the line of sight in your painting and decide which clouds need to be outlined. I use this term lightly because you should not outline the full cloud, only the top ridges of the main shapes. Using a script liner brush or a small round brush, use Titanium White to define the edges of your clouds.

Then mix a batch of light gray and dark gray (those mixed in Step 3) to blend the white along one side. Clean up any patchy spots or rough areas that bother you.

Now we'll move on to the bottom portion of the painting. As you begin to work on this section, refresh any parts of the grassy field that might need it. In my painting, I didn't feel like it was blended enough, so I used the same colors I used for the field in Step 2 to smooth it out. I began by laying down a layer of medium green with my flat brush and blended in some dark green while it was still wet.

Add another line of trees with your small round brush and the same dark green that you used in Step 4. These trees should be lower in the composition and should allow you to still see the first line of trees that has been misted over. I created lumpy triangle shapes across the field with my trees to mimic the movement in the

7

8

sky and keep the line of sight comfortable and uninterrupted. The sky's the star of the show and should not need to compete with the lower half of the canvas.

STEP 7: At this point in the painting, we are done with the sky and will be focusing on the ground. Mix a light green with equal parts Titanium White and Hooker's Green. This will be the color you use to clean up the bottom edge of the tree lines. Drag this lighter green down the canvas a bit to incorporate it into the foreground. You can use your dark green from the previous step to add a little more detail to the tops of the new tree lines if you feel they need it.

STEP 8: Our final step will be to add grass. I am hoping for long, silky-looking grass that is blowing in the wind before the storm arrives. Start by creating a gradient of dark green along the bottom edge of the canvas that fades into

the light green you laid down in the last step. The dark green is mixed with two parts Hooker's Green and one part Mars Black. Since your green needs to get lighter towards the horizon, you will need to mix lighter and lighter mixtures as you work your way up. To do this, simply add touches of Titanium White to your green mixture every time you need a lighter color. You can use a flat brush to quickly create diagonal strokes before using a script liner brush to add the finer details. Each brushstroke should get more and more thoughtful as you near the end of the project.

By the end of the painting I hope you can just about feel the wind blowing through the long blades of grass and imagine your clouds rolling across the sky. Find a good spot around the bottom right corner of your painting and sign your name. You painted this masterpiece and the world should know it.

PERFECT SUMMER SKY

When I fondly think of summer, I envision a warm breeze gently blowing as I sit in the shade beneath a tree to escape the sun's heat. Sometimes you can see shapes and characters in the clouds and chase the shadows they cast on the ground. This painting is all about the clouds in the bright summer sky. Each one is fluffy and playing with perspective depending on its placement.

MATERIALS LIST

8 x 10" (21 x 26–cm) canvas

Acrylic Paint
- Titanium White
- Ultramarine Blue, Red Shade
- Cadmium Yellow Medium
- Hooker's Green Hue
- Payne's Gray
- Mars Black

Paintbrushes
- 1" (2.5-cm) flat brush
- #8 boar hair fan brush
- #4 round brush
- #2 script liner brush

Palette

Towel or microfiber cloth

Clean water

STEP 1: To start this painting, fill the top two-thirds of the canvas with a sky blue color. I used two parts Titanium White to one part Ultramarine Blue and spread the paint quickly with a flat brush. Don't mind any streaks that might appear; the sky is filled with color variation and looks great with a little bit of white not fully incorporated.

1

2

STEP 2: Fill the remaining third of the canvas with a bright, summery green. With equal parts Cadmium Yellow Medium and Hooker's Green, mix a happy yellow-green. Apply this layer with a boar hair bristle fan brush. You will be painting over this later, so don't stress about it being perfect.

STEP 3: I deepened the color of my sky in this step by adding a darker blue made up of equal parts Titanium White and Ultramarine Blue to the top half of the sky. My goal with this step was to create a gradient of light blue along the horizon to a more vibrant blue along the top of the canvas. As you add this darker color, you may need to add a fresh touch of the light, sky blue mixed in Step 1 along the horizon to help the colors blend evenly.

3

Once your sky is dry, use Titanium White and a small round brush, paint some fluffy white clouds. They should be thinner toward the horizon and get wider as they are higher up. I like to start out with a blob shape and add some offshoots as well as wispy pieces going horizontally to add texture and interest to the clouds. You can also dry brush some wispy little clouds around the sky with Titanium White and a dry, clean brush.

STEP 4: Once the white is dry, use the same small round brush to paint some shadows onto the bottoms of the clouds. You can use a light gray made of two parts Titanium White and one part Payne's Gray. The shadows will be concentrated around the thickest part of each shape and around the bottom edge. Don't forget to keep the shadows somewhat irregular—you want this to look natural and not man made.

When you're ready, use that same yellow-green mixture from Step 2 to smooth out the grass with a loaded flat brush. Add a little Hooker's Green toward the bottom of the canvas to make the ground closest to you slightly darker.

4

STEP 5: Now it's time to add the tree. Start by drawing the branches with a script liner brush and Mars Black paint. If your paint is thick, thin it down with a little water until it is fluid and will slide onto the canvas with ease. Gently paint the branches coming in from off the canvas. We will add leaves to the tree branches once the black paint dries. Once you're comfortable with your tree branches, add the shadows onto the ground. To do this, mix a medium dark green with Hooker's Green and a touch of Mars Black. Use your round brush to loosely determine the main shapes of the shadows.

5

STEP 6: Once the previous layer is dry, fill in the leaves around the branches with your yellow-green and a small round brush. Use small circular motions to fill in the bulk and a dabbing motion around the edges for a little space between the leaves on the outer edges of the leaf clumps.

STEP 7: Once everything is dry, add highlights and texture to the leaves and grass on the ground. The highlights on the tree are made with the yellow-green you used for the leaves in Step 6 only with additional yellow mixed in and a small round brush or script liner. Keep the highlights to the upper left-hand side of each clump of leaves.

6

On the ground, use the medium dark green from Step 5 and create little blades of grass in the shadows with a script liner brush. Then use the liner brush to make some light green blades of grass on the ground along the edges of the shadows. This shows off the grass that is highlighted by the sun. For this lighter green, use the yellow-green that you used for the leaves of the trees.

I also used a little bit of Hooker's Green and made light shadows under the clouds, intermingling the little grass blade brushstrokes.

Don't forget to sign this lovely painting of yours once you are done!

7

MOODY FIELDS

The sky is overcast, and fog is settling on the world around you. It's the kind of day for curling up with a cup of tea and watching a spooky movie. The wind is blowing just enough to swirl the grass and rustle the leaves, but not so much that you're worried about the storm that might roll in. It's calm and comfortable.

This painting uses the sky as the primary mood setter, but the landscape frames it and pulls the story together. You will be able to practice using your script liner brush and the fog technique in this moody painting.

MATERIALS LIST

9 x 12" (23 x 31–cm) canvas
Acrylic Paint
 • Titanium White
 • Payne's Gray
 • Hooker's Green Hue
 • Mars Black
Paintbrushes
 • 1" (2.5-cm) flat brush
 • #4 round brush
 • #2 script liner brush
Palette
Towel or microfiber cloth
Clean water

1

STEP 1: Let's plan for the horizon point to be about one-third up from the bottom of the canvas and fill the top two-thirds with a flurry of Titanium White and Payne's Gray. As you paint this section, use your flat brush to pick up your white and gray without mixing them, and start swiping your brush across the canvas. As you mix the colors on the canvas, let them blend but leave some variation in the sky, adding white or gray at random if they blend too evenly.

2

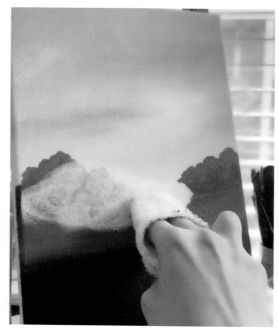

3A

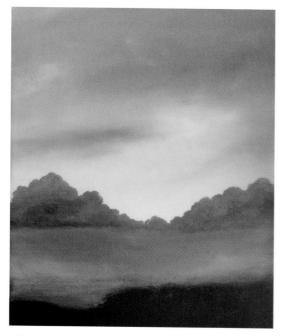

3B

STEP 2: Fill the bottom third of the painting with a dark green and place some clumps of trees along the top. The dark green is equal parts Hooker's Green and Mars Black. Use your round brush to shape the trees with the dark green. Mix up a lighter green and and add it around the tops of the trees for a subtle highlight. This lighter green is a mixture of two parts Hooker's Green, one part Mars Black and a touch of Titanium White. Don't worry about adding tree trunks or branches as they won't be visible later.

If you catch it while the paint is still wet, mix a lighter green and blend down from the horizon a few inches. This is just to start differentiating the foreground (the grass in the front) from the background (the layer of trees in this step).

STEP 3: Wait for your painting to dry completely, several hours or more, before adding a thin layer of fog evenly across the tree line and the top portion of the grass (refer to page 32 if needed).

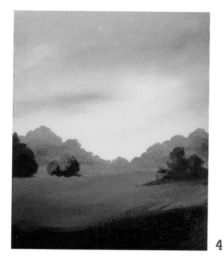

STEP 4: After your paint is dry, reestablish the grass in the foreground by using your 1-inch (2.5-cm) flat brush and a medium green to paint over the mist that covered the grass in the last step. To mix this medium green, use two parts Hooker's Green, one part Titanium White and a touch of Mars Black.

Paint some round, fluffy trees with dark green from Step 2 and your round brush just below the first layer of trees. You can space them out as much as you want or clump them together. Mix a bit of white into your dark green paint to use for the highlights on the left-hand side of each tree.

4

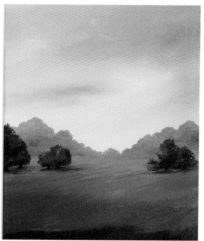

STEP 5: Use your script liner brush and Mars Black paint to make tiny tree trunks under the trees and little branches peeking through the leaves every now and then.

Use the same brush to make diagonal (but nearly horizontal) brushstrokes to start layering in the flowing grass. For the grass, I use three shades of green and mix them as I go on the canvas. Use the same dark and medium greens that you used earlier in this painting and make the lightest green by adding a touch of Titanium White to your medium green. The darkest shade is used as a shadow under the trees, the medium one is used to add texture across the landscape and the lightest shade is for adding accent lines. Make sure to keep the green light towards the horizon line to show depth in the piece!

5

STEP 6: Continue adding grass all the way down the page. Blend the colors enough that the brushstrokes don't all stick out, but not so much that there is no texture for the blades of grass blowing in the wind.

Allow everything to dry before dry brushing some white paint around the horizon line and around the trees.

Finally, take a light green and sign your name in the bottom right-hand corner. Incredible job on this painting! You should be proud.

6

QUIET LAKES

"Stay close to the serenity of a lake to meet your own peace of mind."
-MUNIA KHAN

Lakes have long been a place of peace for humankind. The water is calm and surrounded by beautiful land. Lakes have a special way of reflecting their surroundings and bringing a gentle life to the world. One of my favorite places to escape to and contemplate at is Bear Lake, a couple hours north of my hometown on the border of Utah and Idaho. This lake is nestled in a valley surrounded by mountains and incredible pine trees. The water is always so crisp and refreshing as the snowmelt filters in all year long.

In this chapter, we will explore different lake views with varying reflections, ripples and skies. Each painting highlights a different technique, from minimal paintings focused on value to detailed paintings that build up your brush skills.

MOONLIT WATER

This scene highlights the beauty of moonlight glinting off the ripples in the water with stars sparkling throughout the sky. Each little detail is reminiscent of a quiet night at the lake with the world stopped around you. Time means so little in places like this.

This piece has a minimal color palette that plays with tonal values and pushes you to create depth with your composition and contrast throughout the painting.

MATERIALS LIST

8 x 10" (21 x 26–cm) canvas
Acrylic Paint
* Ultramarine Blue, Red Shade
* Mars Black
* Titanium White
Paintbrushes
* 1" (2.5-cm) flat brush
* #2 script liner brush
* #2 boar hair fan brush
Palette
Towel or microfiber cloth
Clean water

1

STEP 1: Cover the canvas with a mixture of Ultramarine Blue and small touches of Mars Black and Titanium White; I went in and covered the canvas with the Ultramarine Blue first before adding white and black directly to the wet paint and blending them together. Use the flat brush and long horizontal strokes that cover the full width of the canvas. The full surface should be saturated with the paint and a horizon line gently drawn in with Titanium White about one-third up from the bottom of the canvas.

2

3

STEP 2: Use a very dark blue made up of two parts Mars Black and one part Ultramarine Blue to block in the silhouette of a mountain range with your flat brush. Paint a second mountain range reflected onto the other side of the horizon line. The horizon line now symbolizes the surface of a lake!

STEP 3: With a script liner brush or a flat brush, create ripples and lines of moonlight reflecting off the surface of the water. The ripples and light at the horizon line are made of a light blue while the ripples toward the bottom are drawn in with two shades of darkened Ultramarine Blue. The light blue is made of Titanium White with a tiny bit of Ultramarine Blue mixed in. The medium blue is made of Ultramarine Blue mixed with touches of Mars Black and Titanium White. The color for the darkest ripples is a mixture of Ultramarine Blue and a dot of Mars Black. The darker ripples come in at a slight angle while the ripples at the top stay pretty horizontal.

5

6

STEP 4: Paint in a crescent moon with your small script liner brush and Titanium White. Crescent moons can be rather difficult as you need to be able to make a perfect circle without fully closing it. You can trace, freehand or stamp the circle for the moon. To stamp it, take a small round item, add wet paint to the rim and gently place it where you would like your moon to be on the canvas, then lift up.

STEP 5: Use the medium blue you mixed in Step 3 and short, choppy strokes to create highlights on the mountain range. These highlights will only be on the side of the mountains that face the moon.

STEP 6: Cover any parts of the painting that you don't want to have stars, like the mountains or the moon, with a scrap of paper, and flick little stars made of Titanium White paint across the sky and the water. To do this, load your fan brush with white paint thinned with water and hold it perpendicular to your canvas. Flick a clean finger across the top of the bristles so the paint flies off the brush and onto the painting.

With the same light blue used for the ripples in Step 3, add a line of reflection along a few of the dark ripples in the lower part of the painting using your script liner brush.

As you wrap up your painting, make sure to sign your name in the bottom right corner. You are the artist that painted this incredible work.

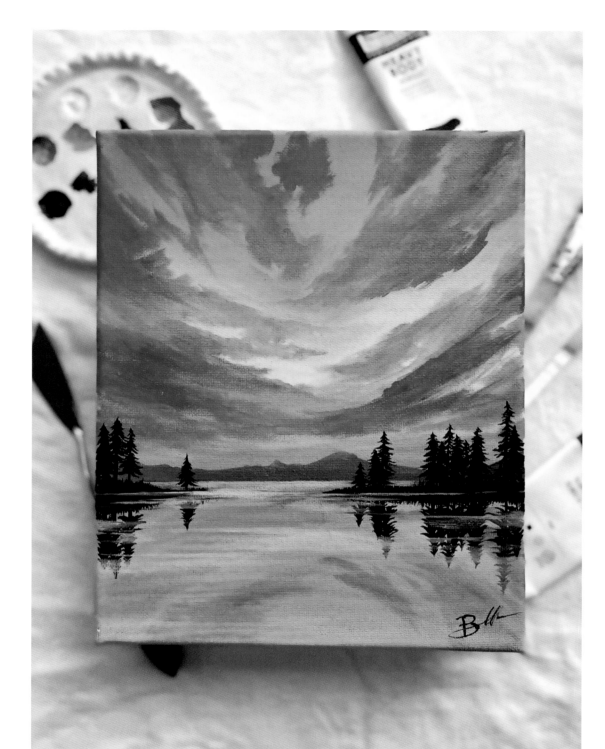

SPARKLING SUNSET

This sparkling sunset plays with so many colors while keeping the scene minimal and quiet. The sky explodes with shades of purple and pink with the reflection following suit, while the trees stand still and the water remains calm. So many different brushstrokes are used in this piece, and I can't wait for you to explore them.

MATERIALS LIST

8 x 10" (21 x 26–cm) canvas
Acrylic Paint
- *Mars Black*
- *Ultramarine Blue, Red Shade*
- *Cadmium Yellow Medium*
- *Cadmium Red Medium*
- *Titanium White*
- *Dioxazine Purple*

Paintbrushes
- *1" (2.5-cm) flat brush*
- *#4 round brush*
- *#2 script liner brush*

Palette
Mist bottle
Towel or microfiber cloth
Clean water

1

STEP 1: Establish a horizon line by painting a dark line across the canvas about one-third up from the bottom with Mars Black paint. Let this dry before moving on.

The sky is filled with Ultramarine Blue, Cadmium Yellow Medium and Cadmium Red Medium, each color fading into the next. Prepare the colors on your palette by adding a touch of Titanium White to each color to lighten them a bit. Then load your flat brush with your blue and saturate the top and bottom edges of your canvas. While the blue is still wet, use a clean 1-inch (2.5-cm) flat brush to pick up the yellow you just mixed and start applying it to the canvas in horizontal strokes that flare up a bit toward the edges of the canvas. Blend the blue and yellow together right where they meet with wide, gentle strokes.

(continued)

2

3

Once you have those colors established, apply the red you have mixed on your palette. This is the final color in the sunset gradient and touches the horizon line. Work quickly so the paint stays wet while you blend. If your paint starts to dry before you are done, lightly mist your canvas with water to keep your paint wet longer.

STEP 2: Start adding clouds by establishing the main shapes with a purple made with Dioxazine Purple and a touch of Titanium White. All of the clouds should radiate outwards from the center. To add depth, keep the clouds closest to the horizon line thinner and less detailed. Use a round brush and quick brushstrokes to form each majestic cloud. Keep the placement of each cloud meaningful but allow your hand to wiggle a little while you paint, to help make sure the clouds don't

look too uniform. Allow the color to vary in the clouds; it is perfectly okay to have some darker spots and some lighter ones.

STEP 3: As you work on the clouds, step back every now and then to look at your painting as a whole. Adjust the number of clouds or the shape of clouds intuitively, filling in empty spaces or touching up any bits that feel too harsh or stiff. For the highlights on the clouds, mix a pink with equal parts Cadmium Red Medium and Titanium White. Add this color to the bottoms of the clouds with your round brush and along the top and bottom sides of the horizon line.

When you are happy with your clouds, mirror the general shape of them onto the surface of the water. The reflection doesn't need to be perfect, but it should match the overall placement! It might help to flip the canvas upside down to paint this second set of clouds.

4

STEP 4: Mix up a dark, desaturated purple with Dioxazine Purple, a touch of Mars Black and a touch of Titanium White, and create a vague mountain range along the horizon line. This is just a silhouette and doesn't need any highlights or shadows. Mirror the image across the horizon line and onto the surface of the lake like you did with the clouds.

To begin differentiating the surface of the water from the sky, use your flat brush to paint light purple lines across the reflection. Use two parts Titanium White and one part Dioxazine Purple for this light purple color. These lines lie parallel to the horizon and don't need too much detail. They will indicate gentle movement in the water.

5

STEP 5: Let the paint dry, and then load your script liner brush with Mars Black paint and create little islands for your pine trees. The ground will appear just above the surface of the water and will have a flat horizontal bottom across the water. Paint delicate little pine trees in the same way you did for Celestial Sky (page 103) across the bits of land with tiny triangular strokes.

Use your script liner to paint the reflection of the pine trees onto the water. You may need to flip the canvas to make it easier to visualize.

When the black is dry, add additional thin lines of light purple and white across the water with your script liner brush. Concentrate the lines along the horizon line to push the water below it further back. Obscure enough of the clouds in the water with these lines that the vibrant sunset doesn't need to compete with its own reflection.

Take a step back and look at the piece as a whole. Adjust any clouds or reflections that might stand out to you. I added some more purple to my sky and a little more yellow to lighten up the harsher lines.

Don't forget to sign your piece with a contrasting color.

REFLECTIONS IN THE WATER

Moody landscapes are filled with soul and feel so comforting to fall into. This landscape holds many secrets as the mist curls down the hill and around the trees that stand tall and strong at the water's edge. This piece highlights the mist technique, dry brushing, multiple types of trees and reflections in the rippling water. You get to paint trees in both realms, on land and in the mirror of the lake.

MATERIALS LIST

9 x 12" (23 x 31–cm) canvas
Acrylic Paint
- Hooker's Green Hue
- Mars Black
- Ultramarine Blue, Red Shade
- Titanium White

Paintbrushes
- #2 boar hair fan brush
- 1" (2.5-cm) flat brush
- #4 round brush
- ⅛" (3-mm) dagger brush
- #2 script liner brush

Palette
Towel or microfiber cloth
Clean water

STEP 1: Establish your horizon line just below the halfway point on your canvas with a dark green line using your fan brush and equal parts Hooker's Green and Mars Black. Above and below this line, make two gradients of sky blue to white, with the darkest color touching the edges of the canvas on both sides. The darkest blue is made with equal parts Ultramarine Blue and Titanium White. Use the flat brush to sweep the color all the way from one side of the canvas to the other while blending the sky blue to white.

STEP 2: Build up a hill with the dark green you used on the horizon line in Step 1. This hill will have a jagged edge on top to imply faraway pine trees. You can use your small round brush to create these little treetops. To take it a step further, use a medium green while you create these trees. For this highlight color, add a bit of Titanium White to the dark green on your palette to create a medium green that is just a couple shades lighter than the base green of the hill. Once you get the shape of your hill figured out, add another hill below the horizon line as a reflection of the one on top.

STEP 3: Wait for this layer of paint to dry completely, then add a layer of fog (refer to page 32 if needed).

2

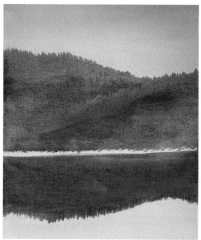

STEP 4: Paint a row of pine trees across the horizon line. To create these trees, use your round brush to make little triangles that start small and get thicker toward the bottom of the tree. When you are finished with the line of trees above the horizon line, paint the mirror image on the water. It might be helpful to flip the canvas upside down so you don't have to paint inverted pine trees.

STEP 5: Wait for this layer of paint to dry completely and cover the entire painting with a new layer of fog. The hill in the background should now have two layers of fog covering it and pushing it further into the background.

3

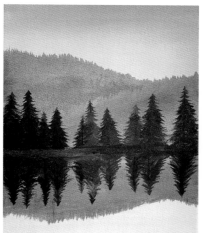

4

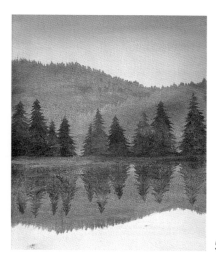

5

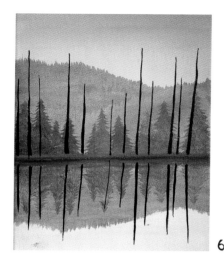

6

STEP 6: Paint along the horizon line with a fresh layer of green. Load your flat brush or fan brush with a mixture of Hooker's Green and a touch of Titanium White to establish this line. Along the horizon line, draw long, tall tree trunks with your script liner brush and Mars Black paint. I like to begin by spacing them evenly and then scatter a few trunks to break up the pattern. If the trees are too evenly spaced, it will look unnatural.

When you are happy with the spacing, mirror the lines onto the water. Try to keep the lines the same as the ones on land, but they don't have to be perfect because the surface of the water distorts images being reflected into it.

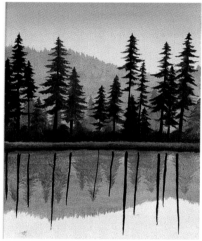

7A

STEP 7: Mix up a fresh bit of the same dark green that you used to paint the hill in the background and use a dagger brush to paint branches onto these trees. Some of the trees may be thicker, but the tallest are sparser and have greater space between each layer of branches. Along the ground, fill the space with some dense foliage. You can use your round brush to shape each bush with little circular strokes.

Flip the canvas upside down and do the same thing on the other side of the horizon line.

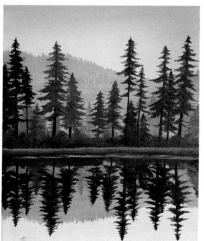

7B

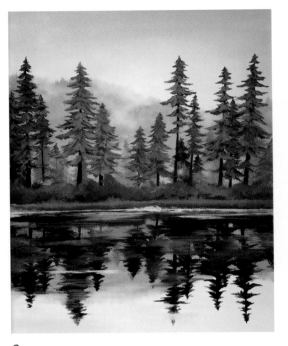

8

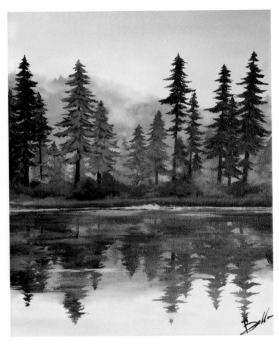

9

STEP 8: This is when you add the final details. Flip the canvas right side up and use a lighter green to add highlights to the trees in the same way that you added the branches. To make this lighter green, you can take the dark green you already mixed and add a bit of Titanium White. You don't want the green to be so light that it looks like snow on the tree, just light enough to stand out against the dark green of the tree. Make sure not to cover up all of the dark green!

Add horizontal lines made of light green and the sky blue used in Step 1 to the water with a script liner brush or a flat brush. This shows the ripples in the water disrupting the reflection with the way the image bounces off the surface of the moving water. You can also take the dark green that the trees are painted with and add little horizontal strokes to the sides of the trees for more movement. Thicker white lines should follow along the shoreline where the water is breaking in tiny waves.

STEP 9: Once everything is dry, add a very thin layer of mist over the water and some small wisps of fog winding through the trees.

Once your mist is dry, take your script liner brush and sign your name in the bottom right-hand corner of the canvas.

MOUNTAIN RESERVOIR

Mountain lakes nestled into the rocky, pine-filled landscape feel like home. The water in this painting accents the landscape above with hints of the mountain peaks and the tops of the pines. You will be carving out mountains, adding reflections to the water, filling the shoreline with silky grass and shaping the sturdy rocks on the water's edge.

MATERIALS LIST

8 x 10" (21 x 26–cm) canvas

Acrylic Paint

- Ultramarine Blue, Red Shade
- Titanium White
- Mars Black
- Hooker's Green Hue
- Burnt Umber

Paintbrushes

- 1" (2.5-cm) flat brush
- ½" (1.3-cm) flat brush
- #4 round brush
- #2 script liner brush
- ⅛" (3-mm) dagger brush
- #2 boar hair fan brush

Palette

Towel or microfiber cloth

Clean water

Pencil

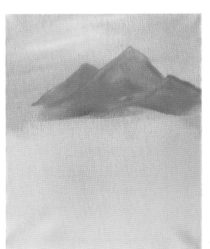

1

STEP 1: Start by mixing up a light sky blue with equal parts Ultramarine Blue and Titanium White. Use your 1-inch (2.5-cm) flat brush to cover the top half of the canvas with this light blue to create the sky. Next, mix medium gray with equal parts Titanium White and Mars Black. Block out a few triangles with your flat brush that will magically turn into mountains with a little texture from you.

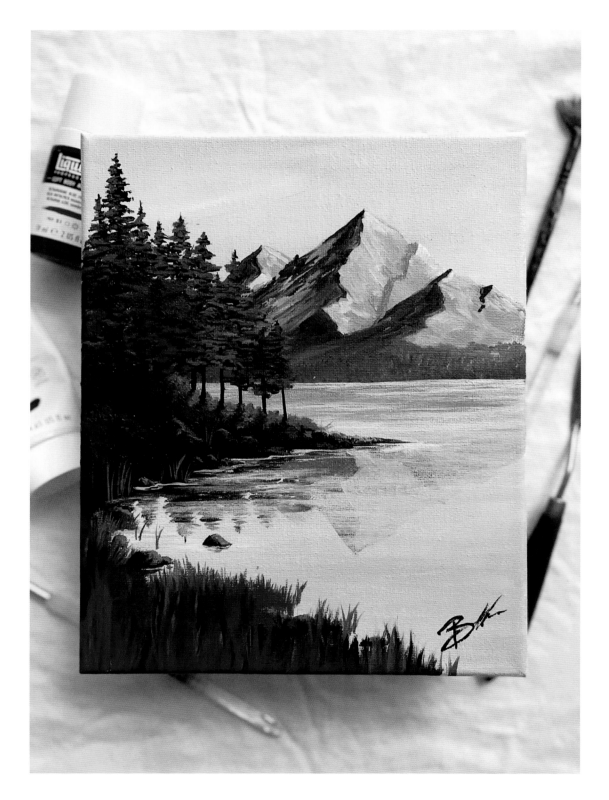

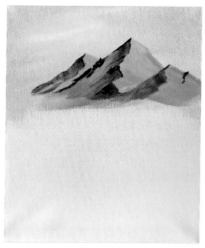

2A

STEP 2: Mix a dark gray with two parts Mars Black and one part Titanium White for the shadowed slopes of your mountains. Use your ½-inch (1.3-cm) flat brush to add some diagonal strokes on the left side of each peak.

Once you're comfortable with that, use the same flat brush to add small highlights with Titanium White on the right side of each peak. The highlights should be at the highest points where the peaks would catch the most sunlight.

Add some greenery to the base of the mountain range with a medium green made up of two parts Hooker's Green and one part Titanium White. You can use your flat brush or your round brush for this step.

STEP 3: Sketch out a coastline on the left side of the canvas with very light pencil marks. This will mark the edge of the lake. Mix up the same sky blue from Step 1 and use your ½-inch (1.3-cm) flat brush to fill in the lake on the right side of the sketch line. Add a light green reflection into the water right below the foliage at the bottom of the mountain range. Mix this up with two parts Hooker's Green and one part Titanium White with a small dot of Mars Black. Apply this with your flat brush, using horizontal strokes to create thin lines that mimic ripples in the water.

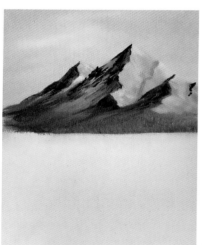

2B

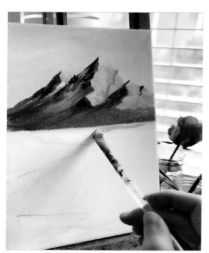

3A

3B

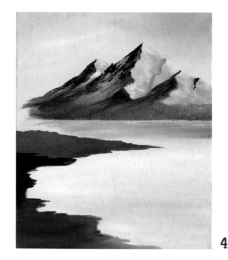

4

STEP 4: Block in the general shape of a rocky outcropping and a grass-covered shoreline. For the rocky outcropping, use a gray made up of equal parts Titanium White and Mars Black with just a touch of Burnt Umber. This outcropping is essentially an acute triangle on the surface of the water.

Using Hooker's Green, fill in the base color for the foliage-filled shore with your flat brush.

STEP 5: Load your script liner brush with Mars Black and paint in some tree trunks along the top of the rocks. Each tree should get taller as it gets further to the left.

Mix up a dark green with equal parts Hooker's Green and Mars Black and use your dagger brush to paint the branches onto the trees. You can switch from the dagger brush to the #2 fan brush for the larger branches if you need to. Make sure to leave enough space that you can see a little bit of sky through the branches. While you still have some dark green, fill the ground below the trees with textured brushstrokes to create some dense foliage. Your #2 fan brush is great for filling in space as well as creating this texture.

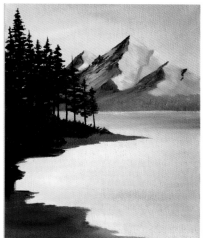

5

STEP 6: Let's add some rocks to the shoreline. Mix up the dark gray from Step 4 to block out the shapes of the rocks where you want them with your round brush. Once you are happy with the little guys, add a shadow to the bottom left-hand side and a highlight to the top right-hand side of each rock. These colors can be made by adding a bit of Mars Black to the gray for the shadows and a bit of Titanium White to the original gray for the highlights. With the same gray used in the highlights on the rocks, make short horizontal strokes just underneath them in the water to create a reflection. Leave a small strip of light blue directly underneath each rock to separate the land from the water.

6

7

8

STEP 7: In this step, we will add some grass details as well as the reflection of the mountain and trees on the surface of the lake. For the blades of grass, use a light green of equal parts Hooker's Green and Titanium White to create quick vertical strokes with your script liner brush. Place a few lone blades of grass into the water just off the shoreline.

For the reflection of the mountain, it might be helpful to turn the canvas upside down to essentially paint the mountains all over again, just in the water instead of the sky—though these mountains don't need to be nearly as detailed.

The reflections of the trees don't need to be perfect mirror images of the trees on land; they can be horizontal strokes in the water in the shape of upside-down triangles. Use the same green that you used to create the grass along the left-hand side of the canvas.

STEP 8: Once the paint is dry, use your script liner brush or your flat brush to create little horizontal strokes of sky blue and white across the water to distort the mirrored reflections a little bit.

Don't forget to sign your incredible piece of artwork! The world needs to know who made it.

LAKESIDE PEACE

The lake falls behind the path through the trees in this piece. I imagine a hike through the woods that leads to a comfortable and sandy shore along a clear lake edge. The trees frame this mountain-clad landscape and play with a new composition.

This piece calls back to brush skills you practiced in previous paintings with the mountains and dense forests in the distance, soft clouds in the sky and textured pine trees in the foreground.

MATERIALS LIST

8 x 10" (21 x 26–cm) canvas
Acrylic Paint
- *Ultramarine Blue, Red Shade*
- *Titanium White*
- *Mars Black*
- *Hooker's Green Hue*
- *Cadmium Yellow Medium*
- *Burnt Umber*

Paintbrushes
- *1" (2.5-cm) flat brush*
- *#4 round brush*
- *#2 script liner brush*
- *#2 boar hair fan brush*

Palette
Towel or microfiber cloth
Clean water

1

STEP 1: To begin this painting, cover the top half of the canvas with a gradient of bright Ultramarine Blue to a light sky blue toward the center. Use your flat brush to apply pure Ultramarine Blue paint to the top portion of the painting and gradually add Titanium White until you have a nice even gradient. While the paint is still wet, take your flat brush, loaded with white paint, and make quick, smooth strokes across the sky to bring forth some clouds. These clouds are not fluffy and full; rather, they will be full of movement and quite transparent.

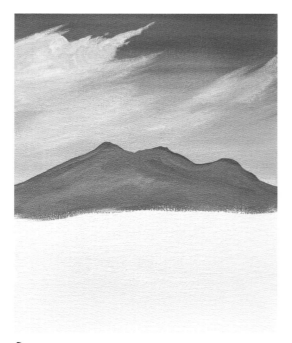

2

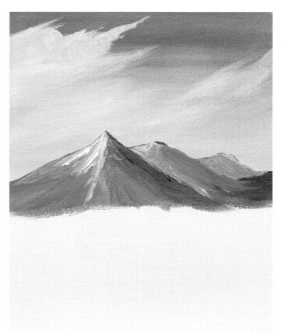

3

STEP 2: Form a cluster of mountains about halfway down the canvas. They should cover the bottom of the gradient you used in your sky. Use your flat brush to mix up a medium gray with one part Titanium White and one part Mars Black. In this step, you only need to quickly block in the shapes.

STEP 3: Use your flat brush to add Titanium White to the left-hand side of each peak and Mars Black to the right-hand side. Your strokes should follow the direction of the slope and can be rather jagged, as this helps create texture in a structure that is far away.

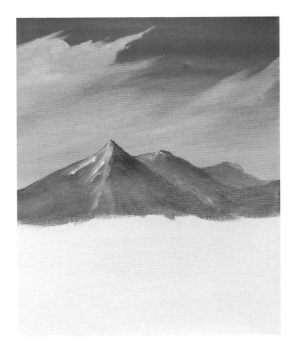

4

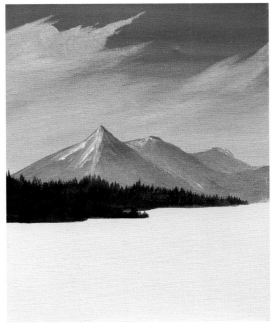

5

STEP 4: Wait for that layer of paint to dry completely before moving on to this next step. Once the paint has dried for several hours (or more), add a layer of fog covering the mountain range (refer to page 32 if needed). Use a clean, damp cloth to spread Titanium White paint across the mountains. The cloth should be damp but not wet, as too much water will agitate the paint underneath and cause a mess. Gentle circular strokes are the best for this technique to cover the subject evenly.

STEP 5: Add a few triangles of dark green to build a forest at the base of the mountain. The dark green is made up of equal parts Hooker's Green and Mars Black. Use your round brush and make short, vertical strokes along the top edge for the tips of the trees in the dense forest. The bottom line of this section should be rather horizontal, as it will be on the surface of the water and too much of a bend will cause it to look unnatural (for more on perspective, see page 27).

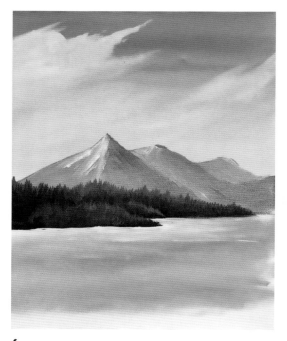

6

7

STEP 6: Fill in the water below the trees with the same sky blue used earlier in the painting. With horizontal strokes, add Titanium White along the shoreline to create ripples in the water.

You can also add a lighter green with your little round brush to add highlights to the forest. The green will be the same dark green mixture, but with added Titanium White.

STEP 7: Now it's time to establish the foreground. For this, use a light green made up of Hooker's Green and Cadmium Yellow Medium to create foliage along the bottom strip of the canvas. I like to use a mixture of round leaves and tall blades of grass.

Don't put too much thought into the placement right this moment, as the foliage may change through the next few steps. This just starts you with a solid base to work with.

Load your script liner brush with Mars Black paint to plan out the placement of your trees. These trees frame your beautiful mountain lake.

STEP 8: Fill your trees with thick, full branches. Each branch swings downward slightly with the weight of the needles and is fuller toward the bottom of the tree trunk. Use Mars Black with a touch of Hooker's Green to create the base for the tree and highlight each branch with a light medium green made with Hooker's Green and Cadmium Yellow Medium.

You can also add some dark branches peeking in on the left side of the painting, to balance out the height from the tree on the right side.

8

9

You'll notice that the foliage changed a lot from the last step. This is something that can naturally happen during your creative process as you play around with the scene in front of you. In this step, I took a darker green and clumped the foliage together along the forest floor to prepare for Step 9. This darker green is made up of two parts Hooker's Green, one part Mars Black, a touch of Titanium White and just a smidge of Burnt Umber.

STEP 9: Carve a path through the foliage along the foreground. This path curves around the trees and heads toward the lake. For the base color of this path, use Burnt Umber and Titanium White. I like to use my #2 fan brush for this and primarily use short horizontal strokes because the added texture brings life

to the packed dirt. The shadows along the edges of the path are made with a mixture of Burnt Umber and Mars Black and can be applied the same way or with a round brush for more precision.

Each tree should receive extra highlights on the left-hand side, and the dense foliage on the ground shines along the top edges thanks to the sun-filled day. Add some extra Titanium White to the green used in the last step for this detail.

Once your lakeside view is finalized, find yourself a spot along the bottom of the canvas that doesn't have a lot going on and sign your name. I used my script liner to sign my name in the less detailed shadows in the bottom right corner of my painting.

SEASONAL CHANGES

"To the attentive eye, each moment of the year has its own beauty, and in the same field, it beholds, every hour, a picture which was never seen before, and which shall never be seen again."
-RALPH WALDO EMERSON

It's amazing how each season feels different, both in temperature and in emotion. As the year rolls on, you find yourself in different worlds entirely. From colorful and chilly fall drives through the forest to blindingly bright and boiling hot summers to sparkling snowflakes falling through the air, the changes are welcome. Even if you live somewhere like Texas, where seasons are mostly decided by what decorations the stores are selling!

SPRING FLOWERS AT SUNSET

Sunsets are often filled with vibrant colors of yellow, orange and red, bursting with life. Those inspiring scenes are incredible and I treasure them in my heart. Sometimes, though, we need something soft and comforting. Spring Flowers at Sunset was painted to honor the incredibly sweet spring days that remind us to slow down and breathe in the cool spring air.

In this project, we will play with pinks and purples in the sky and on the ground. We'll use a round brush, a flat brush and a fan brush to build a sweet field of flowers.

MATERIALS LIST

8 x 10" (21 x 26–cm) canvas
Acrylic Paint
- Titanium White
- Dioxazine Purple
- Cadmium Red Medium
- Hooker's Green Hue
- Mars Black

Paintbrushes
- 1" (2.5-cm) flat brush
- #4 round brush
- #8 boar hair fan brush
- #2 boar hair fan brush

Palette
Towel or microfiber cloth
Clean water

1

STEP 1: Fill the canvas with a layer of Titanium White using a flat brush. While the paint is still wet, gently add small amounts of Dioxazine Purple to the sky with the flat brush. Use horizontal strokes that span from one side of the canvas to the other for a gradient of purple to white.

2

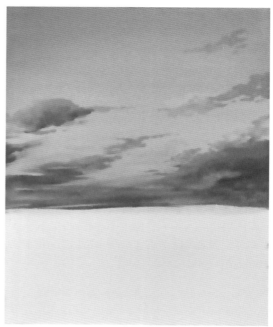

3

STEP 2: If the paint is still wet, add some pink to the halfway point in the canvas and use the same wide horizontal strokes to drag it up into the purple, blending the two colors in the middle. This pink is made with Titanium White and a dot of Cadmium Red Medium. If the paint has dried, add the pink in the same fashion, but you may need to add some fresh light purple to blend the colors.

STEP 3: Once the sky has dried completely, mix a small bit of white into some Dioxazine Purple and use your round brush to create some clouds. Each cloud is made up of small circular motions and horizontal brushstrokes. The clouds closer to the horizon will have less detail and will primarily be made up of horizontal brushstrokes. As you travel upwards, your clouds should start to puff up and spread out.

When you are happy with the cloud placement, build some highlights onto the clouds. Each cloud will have a little bit of a light pink halo as the setting sun kisses them. This pink will be lighter than the pink that was blended into the sky (mainly Titanium White with the tiniest dot of Cadmium Red Medium).

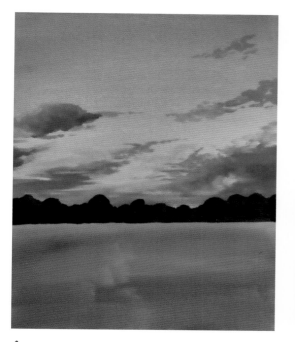

4

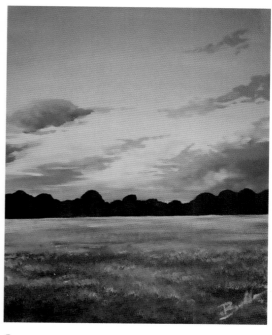

5

STEP 4: Just under the clouds will be your horizon line. Start by using your flat brush to fill the bottom of the canvas with a layer of Hooker's Green. This is simply a base layer for your field and does not need to be very thick or very even. Crown the grass with a dark line of trees. For this dark color, mix a dab of Hooker's Green with some Mars Black. Use your round brush to create fluffy and imperfect trees with little to no detail. They are just silhouettes against the purple sunset. Keep the bottom of the tree line flat across the canvas.

STEP 5: Blooming flowers are some of the most delicate and beautiful little pieces of nature. But, you don't need to paint individual petals to bring flowers to life. Using a mixture of Dioxazine Purple and Titanium White, load your #8 fan brush and gently dab the purple onto the lowest part of the canvas. The flowers will be larger toward the viewer and smaller as they fade toward the tree line. As you get further back, switch to your #2 fan brush and start to swipe your brush to the side rather than dab. Don't cover the full field—you still want to see the grass underneath.

As you finish your painting, take a step back and admire the sunset that you just created. Touch up anything that your heart desires and remember to sign your name!

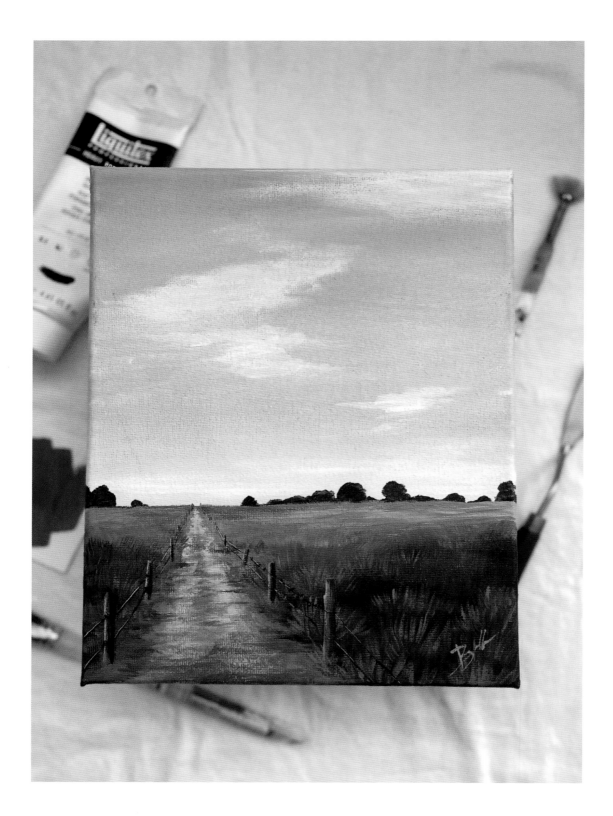

EARLY SUMMER PASTURE

As spring filters into summer, warm and open air invites the world to take a break from busy lives to enjoy the weather. I live in Texas and usually spend my summers inside or at the pool because the heat index can get so high. Instead of enjoying the summer during June and July, I enjoy my summer in April and May when the days are warm but bearable. Summer Pasture is dedicated to those days when you just can't help but go outside and soak up some vitamin D. If you're like me, you might even get to explore the farmers' markets and say hi to some animals in the pastures.

MATERIALS LIST

8 x 10" (21 x 26–cm) canvas

Acrylic Paint
- *Ultramarine Blue, Red Shade*
- *Titanium White*
- *Hooker's Green Hue*
- *Cadmium Yellow Medium*
- *Mars Black*
- *Raw Sienna*
- *Burnt Umber*

Paintbrushes
- *1"(2.5-cm) flat brush*
- *#4 round brush*
- *#2 boar hair fan brush*
- *#2 script liner brush*

Palette

Towel or microfiber cloth

Clean water

Pencil

1

STEP 1: The horizon line is going to hit about one-third up from the bottom of the canvas, separating the sky from the earth. The horizon line represents the point furthest away from us. Therefore, this will be the lightest part of both the sky and the ground. For the sky, use Ultramarine Blue and Titanium White to create a gradient with the lightest part ending at the horizon. For the ground, use Hooker's Green, Cadmium Yellow Medium and Titanium White to create a gradient using your flat brush, with the darkest value being closest to the viewer and lowest on the painting.

STEP 2: While the blue in the sky is still wet, use your round brush to apply Titanium White with circular motions for the clouds in the sky. Because the horizon line is the furthest point from us, the clouds toward the bottom of the sky are thin and have little detail. The higher in the sky the clouds rise, the fluffier and more opaque they are. Try to avoid painting them as uniform, evenly spaced blobs. Clouds are made of water vapor and are rather unpredictable in their movement.

STEP 3: Crown the horizon line with a string of trees. Use your round brush to create the rounded canopies with a mixture of Hooker's Green and Mars Black. The darker value of these trees helps rein in the landscape to a tangible piece of land—a pasture.

STEP 4: Once the paint is fully dry, mix up a light brown using Raw Sienna and Titanium White to use as the base color in your road. This dirt road extends far into the distance and does not curve, making this step as simple as painting a triangle with the smallest point disappearing over the horizon. After you fill in your triangle, use a darker brown to build up the middle of the road to suggest that it is less worn down than the sides. This darker brown is made up of two parts Raw Sienna and one part Titanium White.

STEP 5: Mix up a few shades of green on your palette using Hooker's Green, Cadmium Yellow Medium and Titanium White. You need a light green, a medium green and a dark green. Start by loading your fan brush with the dark green and fill the foreground with clumps of grass. These can be made by stamping your fan brush or by swiping up with the bristles to drag the paint upward. Take a few trails of grass into the road as well.

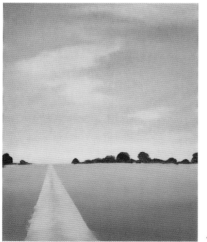

STEP 6: For the lighter grass blades, use your script liner brush to intentionally paint vertical strokes of light green paint around the tops of the grass clumps. You will also need to add some horizontal strokes of light green along the back of the pasture, so it doesn't look oddly smooth compared to the textured grass up front.

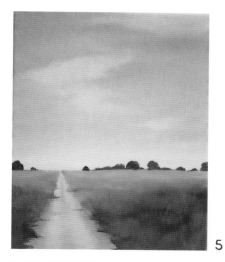

5

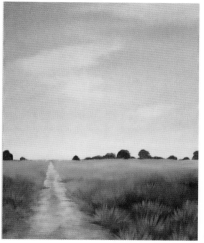

6

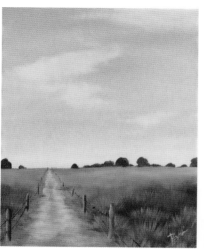

7

While you are adding texture, take a small brush and run horizontal lines of dark brown down the road. This dark brown is made up of two parts Raw Sienna, one part Titanium White and one part Burnt Umber. This path runs through the rural area and is made of hard packed dirt. If it is too smooth, it will look out of place. Concentrate the dark colors in the middle of the road and on the outside edges where they meet the grass.

STEP 7: The final detail of this painting is the fence. The fence supports are simply round wooden posts with wire running between them. The biggest challenge here is to follow the perspective of the road. The posts get smaller and closer together as they get further away. You can lightly draw orthogonal lines radiating from the vanishing point at the top of the road to serve as guidelines, or you can freehand the placement as the posts are often not the same height or in a perfect line along the road.

The posts are painted with a dark brown base and a lighter brown as the highlight on the left side of the poles. The dark brown consists of two parts Burnt Umber, one part Mars Black and a dash of Titanium White. The highlights will be the same formula but with more Titanium White and should be applied with your script liner or another tiny brush, so you have control over where you paint the little lines.

Each post is connected to the next with a line of wire. To create this fine wire, load your script liner brush with Mars Black and slowly paint two rows of wire between each post. Take your time and don't fret if it's not perfect. As you reach the posts, paint horizontal lines with a bit of a curve to suggest that the wire is wrapping around the wood. Once you have your placement down and your black paint dries, add a very thin highlight on the wires with Titanium White and your script liner. These thin lines don't need to be perfect but take care to make them as thin as you can.

Make sure to sign your name once you are finished! I signed mine with a light green and nestled my signature among the grass.

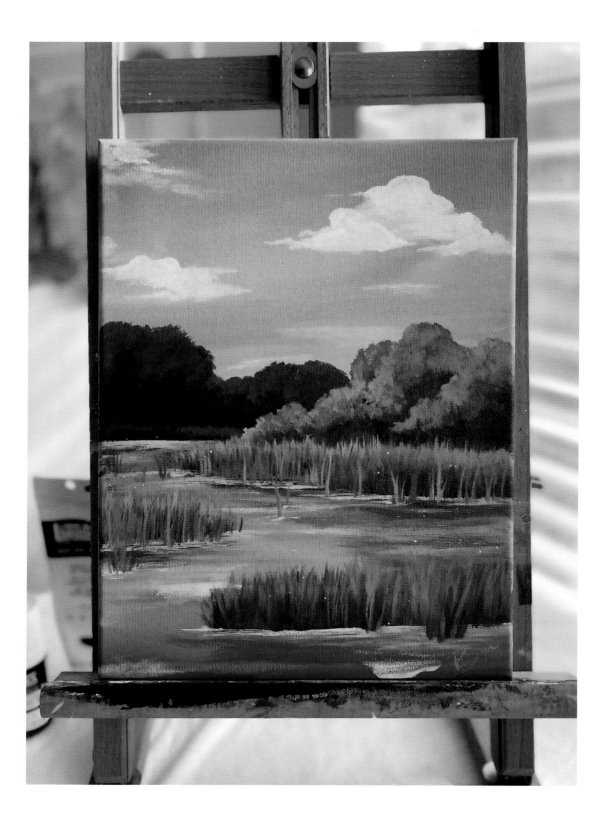

SUNKISSED SUMMER

While the last project was dedicated to the first taste of summer, Sunkissed Summer is meant for those days that you have to spend in the water, or you might melt in the sun. I have experienced many a sunburn while spending a day at the lake or river, and nothing helps you sleep more than a full day out in the summer heat. To capture that feeling, this piece features tall grass in a vibrant, rippling body of water on a sunny day.

MATERIALS LIST

8 x 10" (21 x 26–cm) canvas

Acrylic Paint
- Phthalocyanine Blue, Green Shade (Phthalo Blue)
- Titanium White
- Hooker's Green Hue
- Cadmium Yellow Medium
- Mars Black
- Raw Sienna

Paintbrushes
- 1" (2.5-cm) flat brush
- #4 round brush
- #2 boar hair fan brush
- ½" (1.3-cm) flat brush
- #2 script liner brush

Palette

Towel or microfiber cloth

Clean water

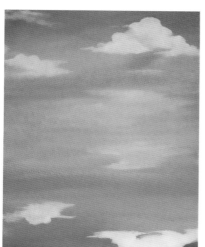

1

STEP 1: In this painting, we are using a different blue than in the other projects in this book: Phthalo Blue. This blue contains *phthalocyanine*, an incredibly vibrant pigment that is rather overpowering. To create the sky, start with Titanium White and add small amounts of Phthalo Blue until you reach the desired shade. Using your flat brush, cover the entire canvas with this blue. During this step, imagine a horizon line running halfway through the canvas. You can draw it on there if you need to. This will act as a mirror as you shape the clouds in the sky and on the water.

(continued)

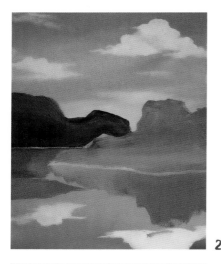

Load your round brush with Titanium White paint and start painting the clouds in the upper half of the canvas. Paint a few blobs and when you are happy with the placement, trail some wispy pieces off to the sides and change any that feel too uniform. The cloud's reflections don't need to be perfectly accurate but should fall in approximately the same place and be around the same shape.

STEP 2: Use your 1-inch (2.5-cm) flat brush to block in the shapes of the trees. Mix two shades of green for this landscape: a dark green made of Hooker's Green and a touch of Phthalo Blue, and a light green made of equal parts Hooker's Green and Cadmium Yellow Medium. The trees in the back are higher on the canvas and darker than the trees on the right. As you establish your placement, loosely color in the reflection in the water. Add a light green area for some grass in the water on the left side of the painting.

2

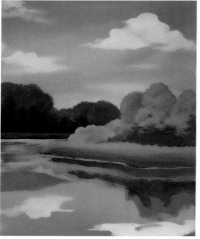

STEP 3: Use your round brush in circular motions to add texture and depth to the trees. Each group of trees stands among thick grass and dense foliage.

Load your script liner brush with a very light blue of one part Ultramarine Blue and two parts Titanium White. Paint some horizontal strokes in the water to form ripples just underneath the tree line in the back.

3

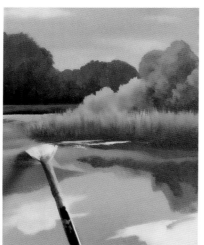

STEP 4: Now let's add some details to the grassy area and water. You can use your fan brush for this whole step. The secret is to fully saturate your brush so that there aren't any stray bristles! For the grass you can just dab the brush onto the canvas while holding it perpendicular to the painting, and for the water you can do the same thing except swiping the center of the brush gently across the image. If you aren't comfortable using your fan brush for the highlights in the water, you can use your ½-inch (1.3-cm) flat brush instead.

4A

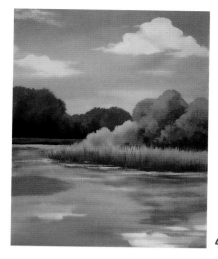

4B

The grass is made with varying shades of green. Mix a light, medium and dark shade of green for the grass. The darkest shade is equal parts Hooker's Green and Cadmium Yellow Medium with a dot of Mars Black, the medium is the same mixture without black and the light green is two parts Cadmium Yellow Medium and one part Hooker's Green.

Start by filling the grassy area with dark green vertical brush dabs and, while the paint is still wet, apply the light green right over it along the top. Do not blend them together any more than they blend on their own. Load your fan brush with the medium green and use this to ease the transition between the lightest and darkest colors. Dab your brush with the medium green only in the middle, just in between the light green and the dark green.

For the water, load your brush with the very light blue mixed in Step 3 and gently swipe across the canvas and around the grass. The highlights are concentrated around the base of the grass and move horizontally rather than at an angle or curve. Use the same technique with a darker blue (the same blue you used to paint the sky in Step 1) to cover some pieces of the green reflection on the right side of the canvas.

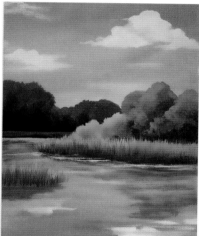

5A

STEP 5: Plan out some more grassy spots in the water and continue with the same technique. Each grouping of grass has ripples in the water that lap along the bottom and might even have a bit of dirt showing in some spots. This dirt is made from Raw Sienna and Titanium White and applied with a #2 script liner brush.

When you're happy with the bulk of the grass, load your script liner with light green and add some blades of grass sticking out of the water with precise vertical strokes.

Sign your painting and show it off to the world!

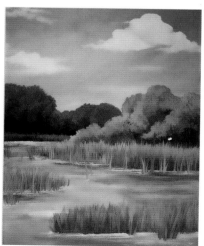

5B

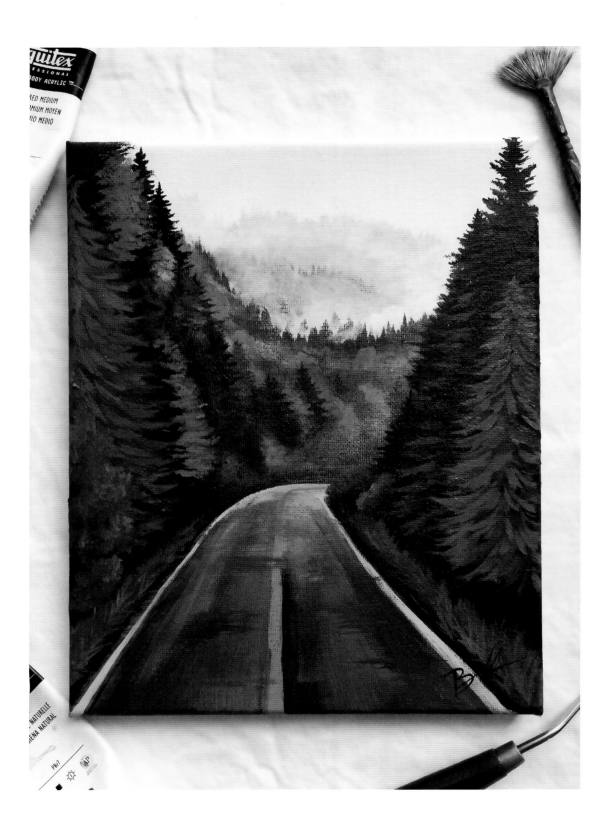

FALL DRIVE THROUGH THE FOREST

As the summer turns to fall and the air begins to cool, the world changes. Bright sunny days get shorter and the forests blossom from green to orange, red and yellow. This painting explores these colors and different textures while creating depth with fog and the perspective of the road curving through the forest. For more information on painting curves in perspective, see page 29.

MATERIALS LIST

8 x 10" (21 x 26–cm) canvas
Pencil
Acrylic Paint
- Titanium White
- Mars Black
- Hooker's Green Hue
- Cadmium Orange Medium
- Burnt Umber
- Raw Sienna
- Cadmium Yellow Medium

Paintbrushes
- 1" (2.5-cm) flat brush
- #4 round brush
- #2 boar hair fan brush
- #2 script liner brush
- ⅛" (3-mm) dagger brush

Palette
Towel or microfiber cloth
Clean water

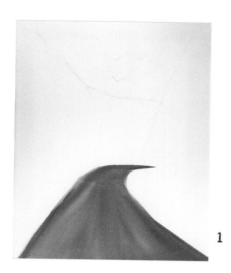

STEP 1: Sketch the overall composition of this painting on the canvas. Use a pencil to draw until you feel comfortable with the placement of everything. You can look at this image or the final image to help you find the perfect placement. Once you're happy with it, fill in the road with your flat brush and a medium gray. For this medium gray, mix equal parts Titanium White and Mars Black.

1

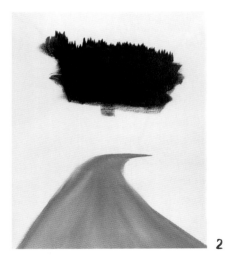

STEP 2: In this step, we will be filling in the layer of trees that is farthest away from the viewer. It may seem odd for it to be floating in the middle of the canvas, but it saves time and paint, so you don't have to fill the whole canvas during every step. This blob of trees is made of a dark green with equal parts Hooker's Green and Mars Black. Use your round brush to build the top edge of this section with pointed vertical brushstrokes, then fill in the rest of this clump of trees with the same dark green.

STEP 3: Let the painting dry until absolutely no part of the painting is wet. Sometimes the paint will try to trick you when the top layer is dry but the paint underneath is still wet. To avoid this, wait for at least 4 hours, or more if possible.

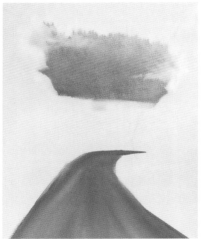

After you're sure it is dry, cover the full dark green section with a layer of transparent fog (refer to page 32 if needed). Sometimes I use the dry brushing technique (page 31) to add little wisps of fog across small sections of the painting to add interest.

STEP 4: Once the fog is dry, add a second layer of trees in front of the first layer. The treetops should not completely cover the previous layer—you want to keep those little trees in the painting. Use the same vertical brushstrokes, round brush and dark green paint mixture as you used in Step 2 to form a line of trees and fill in the bottom bit of this section.

5

6

STEP 5: After waiting for this layer of trees to dry all the way through, cover it completely with Titanium White paint for a layer of fog. Concentrate some of that fog in different areas for a more natural and textured appearance. Dry brushing some of the fog will allow you to control some of the small wisps and cover anything that you might specifically want to cover.

STEP 6: After you are sure the previous layer is dry, once again, fill in this section with dark green and add pointed tops to the top edge of the tree line with your round brush. Once that layer is dry, add another layer of trees. This group of trees is different from the previous two because it includes deciduous trees that have changed color. Intermingle the fluffy orange trees with the pointy pine trees. Mix up a light medium green by adding Titanium White to the dark green color and use your round brush to add little pine trees throughout this bunch of trees. The same round brush loaded with Cadmium Orange Medium works well to form the round tops of the deciduous trees using little circular motions. This layer of trees doesn't need much detail yet, as they are still pretty far away.

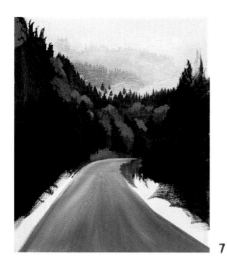

7

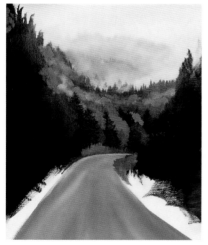

8

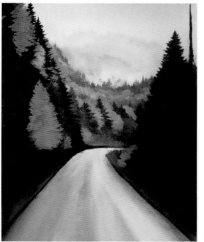

9

STEP 7: Now it's time to extend the forest toward the viewer. Begin by mixing a medium green with Hooker's Green and a bit of Mars Black. Use this color to fill in the area under the trees you have already painted and the sides of the canvas where you plan to add more trees. The trees will get larger and taller as they get closer to the edges of the canvas. With the light medium green that was used in the last step, extend the trees down to the road. The forest is dense and no tree will be seen completely, each one overlapping the one behind it. The dark green works well for the spiky pine trees and the lighter green works for some softer, fluffier pines.

Some of the trees will be painted with Cadmium Orange Medium and the round brush. Small dabbing and circular brushstrokes will help you form these rounded trees. You can use the same round brush to make some dead grass along the road out of a paint mixture made of equal parts Burnt Umber and Titanium White. A little bit of orange mixed in with the grass incorporates the fall colors into the ground.

STEP 8: Wait for the new layer of trees to dry before dry-brushing a haze of mist winding through the trees (refer to page 32 if needed). This mist doesn't extend very far and is focused on covering the tops of the trees.

STEP 9: Extend the colorful forest forward by layering more pine trees and orange deciduous trees. I like to evenly spread the different textures across the forest.

Use your flat brush to frame the road with a rich, dark brown and the undersides of the trees with Mars Black. The brown is mixed with two parts Burnt Umber, one part Raw Sienna and a touch of Mars Black.

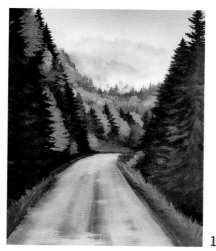

10

STEP 10: Using your fan brush or round brush, bring in the last few trees with a dark green made of equal parts Hooker's Green and Mars Black. The tops of the trees are the most detailed parts as they are thinner and easier to see. I like to use a dagger brush during this stage because it gives you multiple brush-stroke options with its unique shape. Mix a light green made of one part Hooker's Green, one part Titanium White and a dash of Mars Black. Have the brushstrokes sweep downward slightly and fill out the trees toward the bottom.

Use your round brush or your script liner brush to fill the sides of the road with dried grass. This grass is made with Burnt Umber and a little bit of Titanium White.

For the road, use multiple shades of gray and horizontal strokes to add texture and interest. Leave the top of the road the lightest point as it is disappearing around the bend and into the fog.

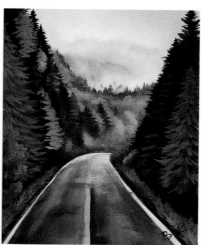

11

STEP 11: Now it's time for the final details in the painting. The trees in the front will be much more detailed than the ones in the back. On the left-hand side, I also added a small orange bush. This bush has multiple shades in it made up of Cadmium Orange Medium, Burnt Umber, Mars Black and Titanium White. To achieve different shades, vary the amounts of each color as you make new mixes. Use your small round brush and circular motions to create this shape.

For the road, there is a yellow line down the center and solid white lines down the sides of the roads. The white lines are actually a very light gray made up of Titanium White and a small touch of Mars Black. Use your script liner brush to carefully follow the sides of the road, tapering the line down as it gets further away. Use the same technique with the yellow line, but with a mixture of Cadmium Yellow Medium and a dash of Mars Black and Titanium White.

Don't forget to sign your painting when it is done! I used Mars Black paint and my script liner for my signature in this piece.

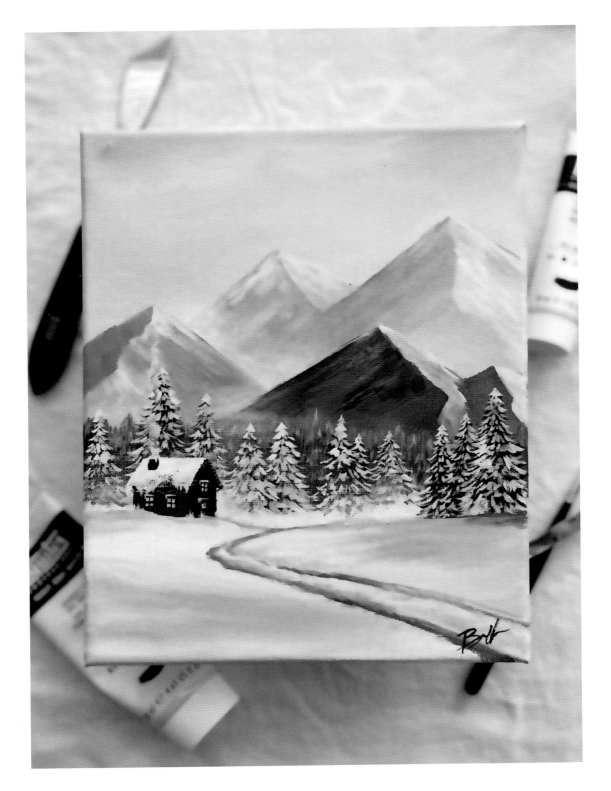

WARM WINTER CABIN

Winter air is fresh and crisp as the snow settles to the ground and blankets everything in sight. Pine trees dotting the landscape hold onto their green warmth while sporting a new coat. This painting explores the textures of snow as paths are carved through it and the warm colors in the cabin contrast the cool colors surrounding it.

MATERIALS LIST

8 x 10" (21 x 26–cm) canvas
Acrylic Paint
- Titanium White
- Mars Black
- Hooker's Green Hue
- Cadmium Red Medium
- Cadmium Yellow Medium

Paintbrushes
- 1" (2.5-cm) flat brush
- #4 round brush
- ⅛" (3-mm) dagger brush
- #2 script liner brush
- ½" (1.3-cm) flat brush

Palette
Towel or microfiber cloth
Clean water
Pencil

1A

STEP 1: To start this painting, mix a light gray with two parts Titanium White to one part Mars Black. Load your flat brush with this gray and cover the top two-thirds of the canvas.

(continued)

1B

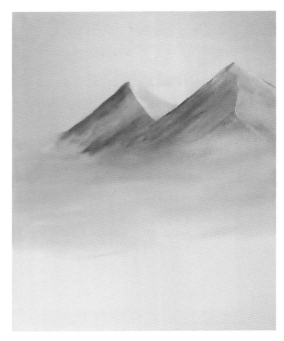

1C

2

Once that layer of paint is dry, use your flat brush and load it with a slightly darker gray to carve out the first layer of mountains. To make this gray, use the same light gray as the sky but add more Mars Black. These mountains are essentially two triangles with seams running down the front. While the gray of the mountains is still wet, you can add a small bit of Mars Black to the left to create streaks for texture and a small bit of Titanium White on the right side to highlight the slopes that are getting the most sun.

STEP 2: Wait for the first layer of paint to dry completely, then add a layer of fog that completely covers the mountains (refer to page 32 if needed).

Add a second layer of fog toward the bottom to thicken up the mist and obscure the lower portion of the mountains.

3

4

STEP 3: When your mountains are completely dry, add another couple just in front of the first ones. You can alter the peaks to your liking, but don't cover too much of the previous group of mountains. Use your flat brush to fill in the new triangular mountains, the one in the back with the slightly darker gray mixed in Step 1 and the one on the right with a darker gray (add more Mars Black to your mix). Sparingly apply Titanium White to the right sides of the mountains while the paint is still wet to highlight the slopes on the right. Once this layer of paint is dry, you can dry brush some white fog toward the bottom of the mountains.

STEP 4: At the bottom of the mountains, use your round brush to create two layers of small trees. The first layer of trees will be made of light green and the second made of a darker green. For the first layer of trees, mix a light green made of one part Titanium White, one part Hooker's Green and a small dot of Mars Black. These trees don't need to be detailed; they can be simple vertical brushstrokes with points on the top. Once that layer of trees is dry, mix a darker green with Hooker's Green, a dot of Titanium White and a dot of Mars Black for the second layer of trees. Utilize the same vertical brushstrokes for the pointed treetops.

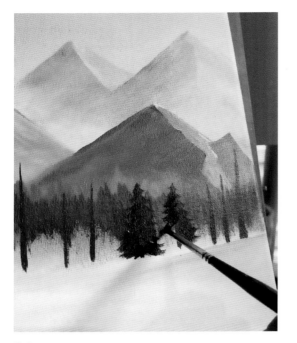

5A

5B

6

STEP 5: In front of the distant trees is a row of more detailed pine trees. The closer the tree is to you, the more detailed it will be. Create the base of each tree with a dark green made of equal parts Hooker's Green and Mars Black and a small dagger brush or round brush, much like the ones in Frosty Pines (page 61).

Once the trees are completely dry, they're ready for snow. Each tree will be dusted with snow and decorated with little triangles or V shapes on the branches. You can use your dagger brush or your script liner brush loaded with Titanium White for this detail.

The foreground of this painting is primarily snow. To start building up the snowy mounds, cover the canvas underneath your new trees with your flat brush loaded with Titanium White paint. While the paint is wet, add a small dab of Mars Black to your brush (still loaded with white) and begin blending the black onto

7A

7B

the canvas. You want this to create light gray triangles in the snow to suggest little hills. One of them is just under the few trees on the right side of the canvas and the other is larger and on the lower left-hand side. If it turns out too dark, add some more Titanium White to your brush and continue blending.

STEP 6: Allow your new trees to dry for several hours. Once they are fully dry, add a layer of fog over the trees in the center and left-hand side of the painting, avoiding the cluster on the right-hand side (page 32). Let this dry completely before moving on to the next step.

STEP 7: Nestle a small cabin into the snow on the left and with a pencil, lightly sketch a path someone took through the snow. My cabin has deep red walls with little windows glowing from the warm light inside. I used Cadmium Red Medium for the walls and Cadmium Yellow Medium and a small flat brush for the

window panes. For the roof, I used a mixture of Cadmium Yellow Medium with a bit of Mars Black and a small flat brush. I used that same color and a script liner to add the window trim. In the end, once the cabin was dry, I added a little chimney poking up through the blanket of Titanium White snow on the roof. Tiny Christmas lights made with the script liner decorate the gutters and snow collects on the window frames.

For the path, using your round brush, paint the main lines using a light gray of two parts Titanium White and one part Mars Black. While the paint is wet, use choppy little brushstrokes to smudge the lines and carry a little gray into the snow along the sides of the path. Don't forget to have a little path running up to the door of the cabin. Add any finishing details like additional texture to the mountains or shadows to the pines before signing your gorgeous, snowy painting.

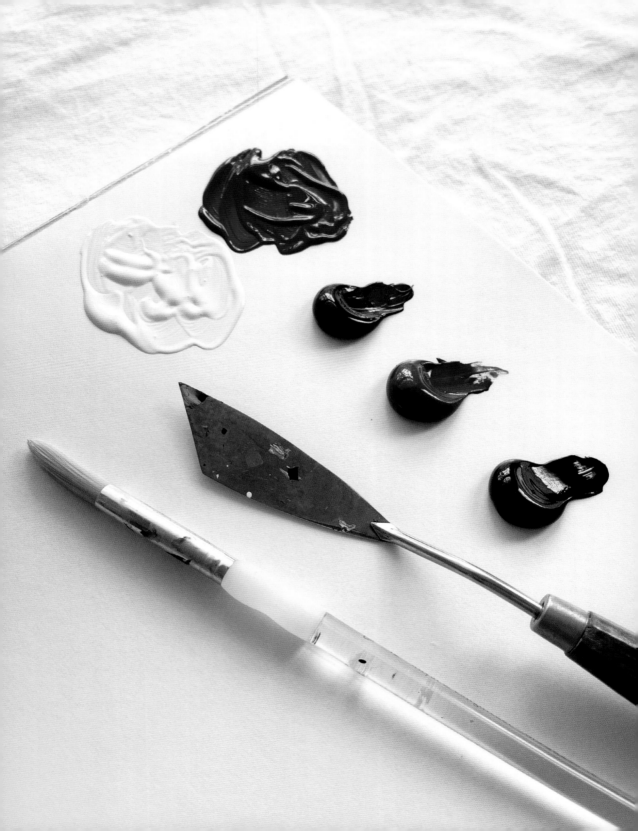

GOING BEYOND THE BOOK

My goal for this book is to introduce you to the world of acrylic painting and to help you paint the incredible world we live in. We explored mountains, forests and lakes together as you took each environment and brought it to life with your acrylic paints. As you build your technical skills and understanding of each tool, I want to push you a little further to begin creating your own compositions.

Building your own world can be a little intimidating. Whether you work from your imagination or you follow a reference photo, I have a few tips for how to move through it.

PLANNING YOUR PAINTING

When you are getting ready to sit down and paint something, you need to wrap your mind around the piece so you have a clear direction to work in. You don't need to have every detail figured out, but it is so helpful to decide on a composition, the story you want to tell and what colors you're going to use in the painting. Two questions you should ask yourself before starting your painting are:

- *What do you want to say? (What is your big idea? What is the message you want to communicate?)*
- *How are you going to say it? (How are you going to arrange the pieces of your painting in a way that communicates your message?)*

A great way to establish this before pouring your heart into a large project is to make a thumbnail painting. A thumbnail painting is essentially a very small and quick version of your painting to make sure the colors go well together and that you like the composition you are using. This may take a few tries, but it's much easier to troubleshoot at this stage than when you've spent hours on a large painting.

COLORS

Before starting a painting, you should think about your color combination to ensure it tells the story and defines the emotion you want in your painting. We covered the color wheel and various color combinations earlier in this book (page 21). You can absolutely use your understanding of color relationships to your advantage as you plan your paintings. For example, a complementary color scheme could be used for an energetic and active scene, while an analogous color scheme could be used for a calm and peaceful environment.

In addition to the color scheme, you should determine whether you want to achieve a warm, cool or neutral (balanced) feel. When I say neutral, I don't mean that you should just use white, black and gray, but rather an equal balance of warm and cool colors.

COMPOSITION

Composition is the arrangement or placement of visual elements in a piece of artwork. Although any piece of music, writing, painting or sculpture can be referred to as a composition, the term usually refers to the arrangement of elements within a work of art.

Works of music are also referred to as compositions. There is a structure to a song. Each musician plays their part. If a musician plays at the wrong time or plays the wrong notes, then the song becomes a mess. Each part is carefully crafted so that the song is the best that it can be. In some songs, the guitar may have more parts and dominate the song. In others, it may be the piano.

As artists, we plan this structure and execute it as we create art. If we don't carefully plan the elements that we include, our art can become a real mess. Luckily, composition is one of those things that can be done with a little practice and planning.

COMPOSITION VS. COPYING THE REFERENCE

It's worth noting the distinction between composing a painting and merely copying a reference, whether that's another work of art you are studying, a photograph you're painting from or the actual landscape in front of you. Many artists go to great lengths to copy a reference with complete accuracy, but you don't get points for being able to copy the reference. People don't see what you painted from—they only see your painting. So your painting must be able to stand on its own. There will be times when you should step away from the reference. Perhaps there's something about it that doesn't read well, is misleading or doesn't fit with the rest of your painting. Your artistic license gives you the privilege to ignore, add or change the reference as needed.

ELEMENTS IN COMPOSITION

There are too many large and small decisions and elements that affect the success of our compositions to list them all. Some crucial things we need to consider as we approach or begin to plan our paintings are:

- *Light and shadow (which change rapidly when painting on location)*
- *Position (left, right, angle and distance)*
- *Perspective (high or low)*
- *The focus of the painting (what you want to convey)*

There are a ton of different design principles, definitions and terms. It's impossible to explore every theory or thought out there, but here is a list of the basic design principles and elements that are at the base of most compositions.

There are **Design Principles** (the visual tools that help us create compelling compositions):

Lines

Lines are much more than the outlines of objects. They contribute to incredible expression, rhythm, movement and harmony in our paintings. They can also lead the viewer where we want them to travel, with both actual and implied lines.

Shapes

How can we group colors, values and lines into shapes? Grouping everything into shapes allows us to separate our thoughts from unnecessary detail in the early stages of painting. It helps us create pattern, unity and movement without the initial distraction of the millions of small nuances and variations that exist in our scene.

Color

Color can be used to harmonize, balance, create movement, produce rhythm and generate emphasis throughout our designs. It controls the emotions of the viewer as well as the focus.

Value

Value is one of our best tools for creating contrast and leading the viewer around our design and, ultimately, to the center of interest.

Perspective

Some of the strategies we can use for depicting space or depth are proportion, shading (values), overlapping, foreshortening, position and clarity (think atmospheric perspective).

There are **Design Elements** (how we use the principles of design to convey the intent of our paintings):

Proportion

How do things fit together and relate to each other? Proportion refers to the objects in your composition and their height, depth and width in relation to the other elements in your artwork. This is the most obvious quality of composition.

Emphasis or Focus

Where is the viewer's eye drawn? Creating contrast and playing with balance, rhythm or movement can make certain elements of a piece stand out and appear more important.

Balance & Unity

Do all of the elements work together? Symmetrical compositions instill a sense of order and calm (think Wes Anderson), whereas asymmetrical ones create more dynamic and active pieces.

Rhythm & Movement

What is happening in the image and how does it draw your eye? Leading lines and underlying shapes and tones can direct the viewer to focus on certain elements or give a sense that a piece is going somewhere at a certain pace.

Pattern

Do elements of the composition repeat? Using repetition can give clear structure or draw certain parts of an image together.

Contrast

How do elements of the piece appear different? Contrast may come in many forms including hue, tone or scale and can create dynamics within a piece.

COMPOSITION TYPES

Proximity

The closer objects are to each other, the more likely they are to be seen as a single group or pattern, or even as a single entity, rather than as individual separate shapes. That doesn't mean they have to feel like one object. Proximity can create tension as well, as seen in Michelangelo's *The Creation of Adam*. Where Adam's and God's fingers almost touch, Michelangelo is using proximity to unify the figures as well as create dynamic tension and powerful expression.

Similarity

Just like it sounds, similarity occurs when the objects or elements we see look like one another. When characteristics such as color, texture, shape, size, value or direction are repeated in a painting, they create unity because of similarity. You can see this in Frosty Pines on page 61.

Closure

When we see a familiar shape or object, like a square or the wall of a building, and that shape is broken by a flower bush or beam of light, our brains will fill in the broken line or "close" the shape.

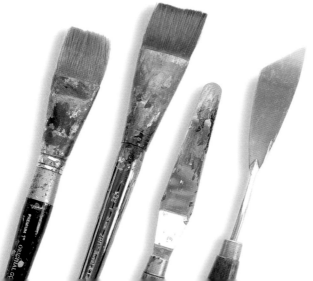

Continuity or Continuation

The easiest way to think of this is when it feels like someone is looking in a specific direction. One way to accomplish this is to use a figure staring in a certain direction in the painting. The viewer's eye will tend to follow the line of sight. An implied line is created which the viewer follows. We are compelled to move from, or through, one object to another. I often use continuity in my paintings by pointing a group of trees, a road, or negative space in the sky to guide the viewer through my paintings.

Rule of Thirds

You've probably heard about this one; it's extremely popular among painters and photographers. In the rule of thirds, you divide your painting with two vertical and two horizontal lines into nine equal rectangles—or more simply said, you divide it into thirds. The idea is to place our center of interest near or at one of the intersecting points (where the red dotted lines converge). That gives us an easy way to keep the center of interest in an asymmetrical position (or a spot more interesting for the viewer than right in the middle).

I often use the rule of thirds in my work. Moonlit Water (page 125) features a horizon line crowned with mountains on the bottom third of the painting. You can also see it in most of my paintings with roads: I try to line up the top of the road with the bottom third line.

It's easy to get lost in all the composition rules and theories. So always try to bring it back to the two questions I brought up earlier. Doing this will also give you more focus and direction going into a painting. Most composition mistakes happen due to a lack of direction. You start a painting with a certain vision, but then something else catches your eye and you pursue that. It's not long before your initial vision is completely lost and your painting is a confused mass of ideas.

We don't need to obsess over the theories and details of composition "rules" or guidelines. Once we have a decent grasp of what has been discussed and discovered by artists thus far, we can move forward and follow our instincts. Enjoy it—have fun and don't fret. Experiment, reflect and play, and see what exciting discoveries you make as you craft your own unique and ingenious designs.

ACKNOWLEDGMENTS

I want to take a moment to thank some very special people in my life. Without them, this art journey and writing adventure wouldn't be possible.

For my husband, the love of my life, who has been here for me with unending support from the moment I met him. For the man that has pushed me to stay true to my heart every step of the way and is lovingly invested in every project I work on.

For my son, the light of my life, who sits with me while I paint and tells me how beautiful everything is, whether I can see it right then or not. For the little boy with never-ending love and light for his mama.

For my parents, who have supported my love of art from the beginning. Without the opportunities they provided and the love they showered me with, I wouldn't be the person I am now.

For my in-laws, who love me like their own and have nurtured me through the difficult times and the times filled with joy.

For my best friends, for encouraging me and supporting me for years. Each one has spent hours brainstorming with me and lifting me up with their friendship and love.

For my editor and her team for guiding me through this process and for encouraging me with their kindness and expertise.

And for everyone that has helped me with my son as I spent many hours on this book. It's rather boring for a 5-year-old when his mama is typing and painting away the days. He spent lots of time being loved on and played with by some pretty amazing people.

ABOUT THE AUTHOR

Sarah Johnston is an artist, wife and mother based in Conroe, Texas. She is widely known as Brellian on her social media channels and specializes in acrylic painting, focusing largely on landscapes that honor the beauty of the world around us. She has had the privilege of working with Michaels on several campaigns, and her paintings have been viewed by millions of people across the world. Sarah also has the privilege of teaching an acrylic painting class at her local art league that she adores.

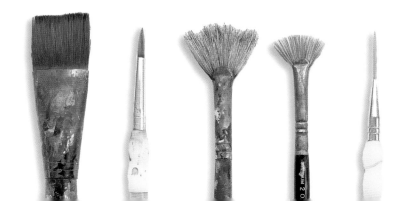

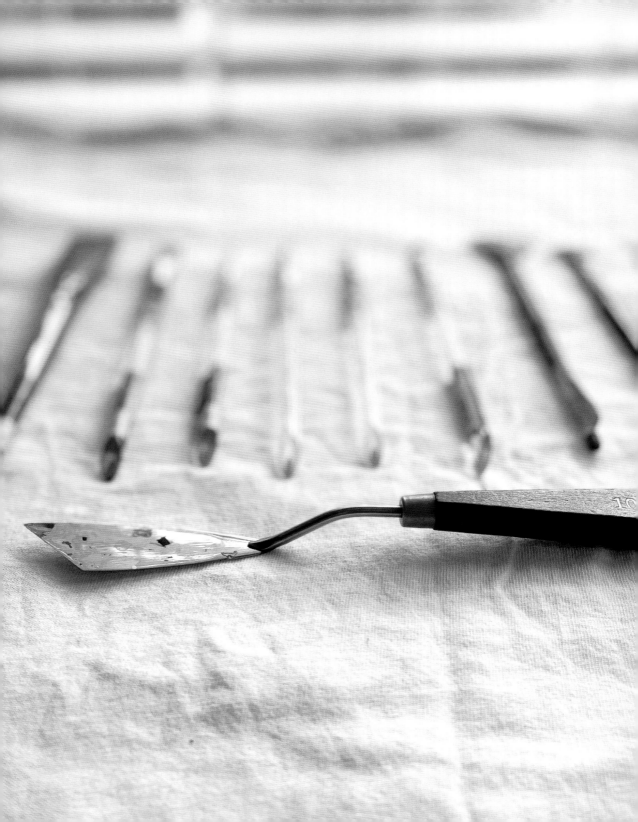

INDEX

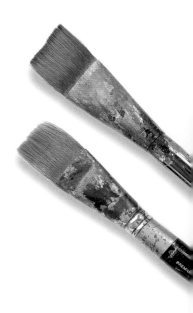

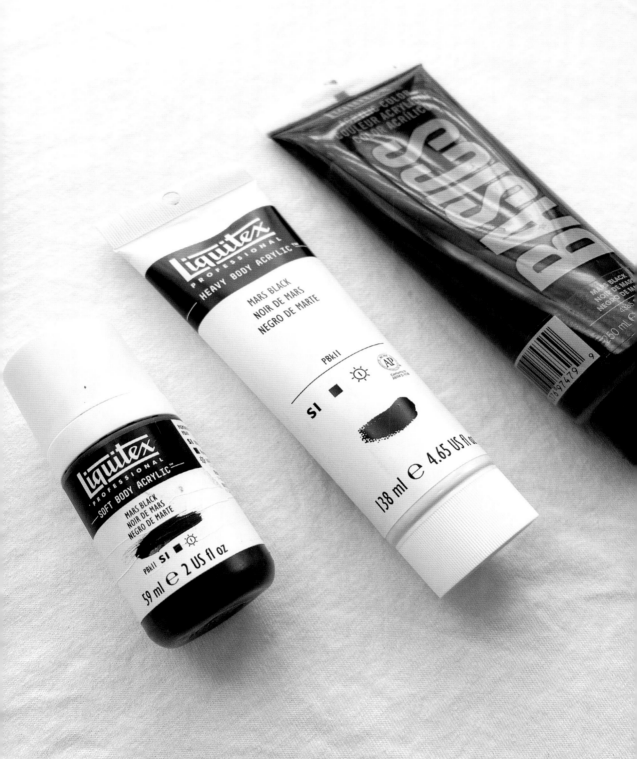